# American

# Silverplated Flatware

# Patterns

ISBN 0-87069-224-0
Library of Congress Catalog
Card Number 79-63289

Layout and Design by Marilyn Pardekooper

Published by

Wallace-Homestead Book Company
1912 Grand Avenue
Des Moines, Iowa 50309

*Dedicated to my husband, Robert E. Snell*

*and my son, Alexander and*

*In memory of my parents, Louise and Alexander Karas*

# Acknowledgements

My appreciation is extended to the following individuals for the following reasons: Walter Lane of the Lane Studio in Gettysburg for photography; Steve Thomas of the Dauphin County Library System for his faithful assistance in arranging inter-library loans of numerous old catalogues from universities and historical societies across the country; and to those individuals who responded to Mr. Thomas' request for them on my behalf; Mr. E. P. Hogan of the International Silver Company in Meridan, Connecticut, for his professional help and many personal kindnesses over the past ten years; Mr. Byron Haverly-Blackford for advice, professional guidance and inspiration; and Mrs. Ann C. Matesevac for transcribing the manuscript portions of the book.

There is a different, almost reverent, type of appreciation that a patient who was seriously ill extends to the physicians who provided care. And it is that special type of feeling I wish to convey to Dr. George R. Moffitt, Jr., Chief of Cardiology and Dr. George L. Jackson, Director of Nuclear Medicine, Harrisburg Hospital, Harrisburg, Pennsylvania.

In addition, I wish to thank my patient and understanding husband Robert, my son Alexander and his wife Tina, daughter of Mr. and Mrs. G. Mehrle Feeser of Gettysburg, Pennsylvania, and my colleagues whom I name here with pride: Mrs. Regina Dunkinson, formerly Head Nurse of Pediatrics at Harrisburg Hospital, and currently Chief of the Bureau of Medical Assistance Policy Division; Mrs. Nancy L. Wilson, first Assistant Director of Nurses for Milton S. Hershey Medical Center; Mrs. Janet Fetterholf, and Mrs. Margaret Zimmerman, Bureau of Medical Assistance Policy Specialists, Mrs. Nancy H. Carey, formerly Medical/Surgical Charge Nurse for the Tri-County Hospital, Springfield, Pennsylvania; and Mrs. Deborah Matz, former Assistant to the Deputy Executive Director of the Governor's Council on Drug and Alcohol Abuse.

Others I am grateful to for encouragement and a variety of supportive services are Mrs. Margaret Keisling, my friend and neighbor; David and Connie Delbaugh, Liverpool, Pennsylvania; Frances Marvin and Elizabeth Johnson, Harrisburg; Mildred Koveleski, Verna and Louise Zenel, Shamokin, Pennsylvania; Alexander Zenel and sons, Wilmington, Delaware; Joseph Zenel and family, Princeton, New Jersey; Anna Louise (Chemeleski) Hummel and family, New Jersey; Janine Wilson, Middletown, Pennsylvania.

# Introduction

Many years ago I began researching silverplated flatware patterns on the premise that an important part of America's heritage would be lost in history unless interest in it was stimulated on a nationwide basis. The Wallace-Homestead Book Company agreed with my philosophy and as a result this is my fifth book on the subject of American silverplated flatware. Hopefully, it will inspire you and others in decades to come to collect it, enjoy its beauty and usefulness, and then hand it down to future generations as prized possessions.

The book is divided into two parts. Section I covers the identification by trademark of the majority of flatware patterns manufactured in the United States over the past 125 years. The word "circa" as used in Section I is an approximation of date, and because researchers in this field do not use the same data sources, will be open to debate in some instances.

Section II contains useable facts for collectors, antique dealers and anyone who would like to operate a silverplated flatware matching service. In addition to basic information about manufacturers' trademarks, composition of base metals and quality symbols, Section II outlines 200 types of utensils to collect. Also included is a subsection about the monograms on flatware produced for railroad companies, and most important of all, an explanation of why silverplated flatware is a sound investment in view of all that is taking place in this country's economy.

# Table of Contents

# SECTION I
# Pattern Identification

# Index to Manufacturers' Trademarks

# Alvin

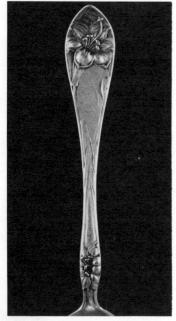

*Pattern:* Easter Lily
*Circa:* 1907

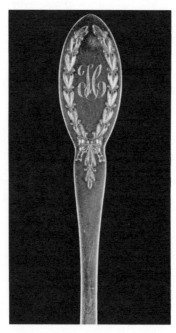

*Pattern:* Diana
*Circa:* 1910

*Pattern:* Louisiana
*Circa:* 1924

*Pattern:* Luxor
*Circa:* 1924

*Pattern:* Lexington
*Circa:* 1910

*Pattern:* George Washington
*Circa:* 1929

*Pattern:* Molly Stark
*Circa:* 1916

*Pattern:* Lancaster
*Circa:* 1923

*Pattern:* Brides Bouquet
*Circa:* 1908

*Pattern:* Victory
*Circa:* 1919

*Pattern:* Dawn
*Circa:* 1929

*Pattern:* Melody
*Circa:* 1930

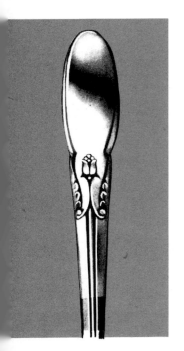

*Pattern:* Cameo
*Circa:* 1935

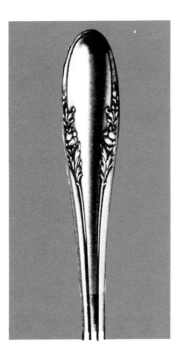

*Pattern:* Fashion Lane
*Circa:* 1941

*Pattern:* Classic
*Circa:* 1925

*Pattern:* Lafayette
*Circa:* 1915

# American Silver Co.

*Pattern:* Warwick
*Circa:* 1919

*Pattern:* Franconia
*Circa:* 1922

*Pattern:* Windsor
*Circa:* 1900

*Pattern:* Tipped
*Circa:* 1900

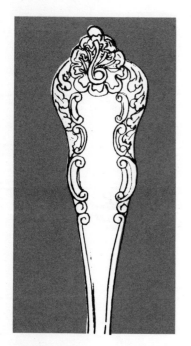

*Pattern:* Laurence
*Circa:* 1901

*Pattern:* Erythronium
*Circa:* 1905

*Pattern:* Holly (Ilex)
*Circa:* 1905

*Pattern:* Marathon
*Circa:* 1909

*Pattern:* Monticello
*Circa:* 1908

*Pattern:* Roanoke
*Circa:* 1913

*Pattern:* Ponce de Leon
*Circa:* 1903

*Pattern:* Vincent
*Circa:* 1910

*Pattern:* Berlin
*Circa:* 1905

*Pattern:* Lorraine
*Circa:* 1891

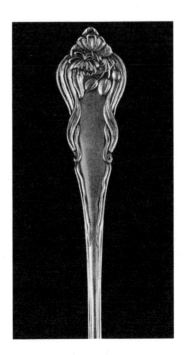

*Pattern:* Nenuphar
*Circa:* 1904

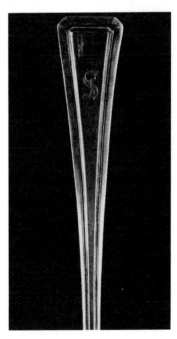

*Pattern:* Somerset
*Circa:* 1914

# American Silver Co.

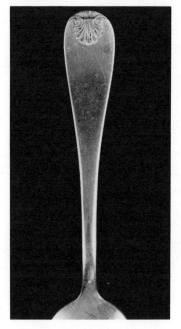

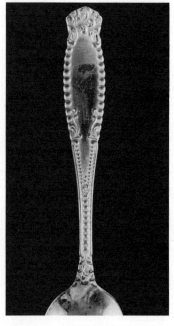

Pattern: Shell
Circa: 1902

Pattern: St. Paul
Circa: 1907

Pattern: Tours
Circa: 1901

Pattern: Moselle
Circa: 1906

Pattern: Adonis
Circa: 1914

# American Sterling Co.

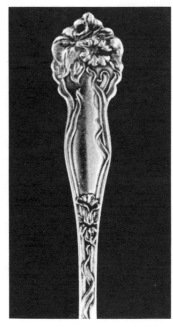

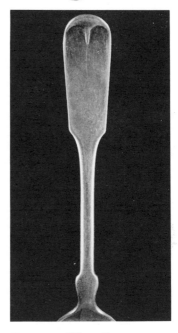

*Pattern:* Priscilla
*Circa:* 1907

*Pattern:* Peerless
*Circa:* 1907

*Pattern:* Tipped
*Circa:* 1907

# Associated Silver Co.

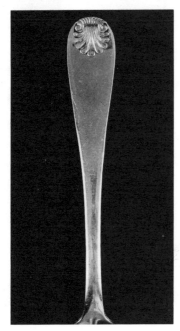

*Pattern:* Shell
*Circa:* 1910

*Pattern:* Windsor
*Circa:* 1910

*Pattern:* Tipped
*Circa:* 1910

# Aurora S. P. Co.

*Pattern:* Royal
*Circa:* 1880

# Benedict Mfg. Co.

*Pattern:* Benedict No. 2
*Circa:* 1900

*Pattern:* DeWitt
*Circa:* 1901

*Pattern:* Lafayette
*Circa:* 1900

*Pattern:* Fairfax
*Circa:* 1909

# E. A. Bliss Co.

*Pattern:* Shell
*Circa:* 1895

# L. Boardman & Son

*Pattern:* Wilton
*Circa:* 1900

*Pattern:* Olive II
*Circa:* 1870

*Pattern:* Persian
*Circa:* 1870

*Pattern:* Plain
*Circa:* 1850

17

# L. Boardman & Son

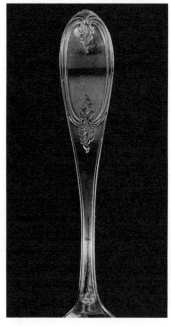

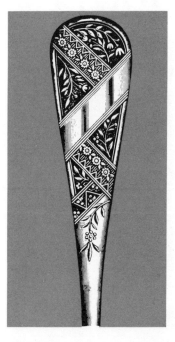

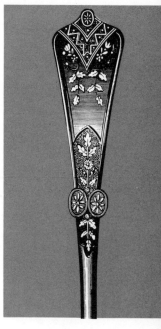

*Pattern:* Tipped
*Circa:* 1850

*Pattern:* Olive
*Circa:* 1850

*Pattern:* Oval Threaded
*Circa:* 1860

*Pattern:* Rogers
*Circa:* Prior to 1905

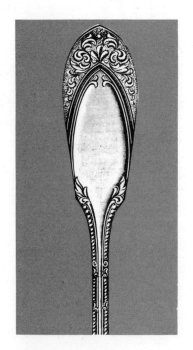

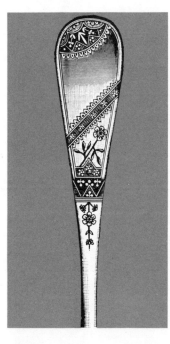

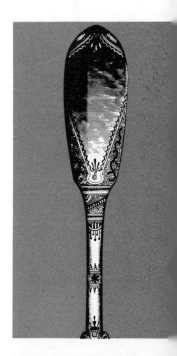

*Pattern:* Congress
*Circa:* Prior to 1905

*Pattern:* Warwick
*Circa:* Prior to 1905

*Pattern:* Barton
*Circa:* Prior to 1905

*Pattern:* Geneva
*Circa:* Prior to 1905

*Pattern:* Doulton
*Circa:* Prior to 1905

*Pattern:* Imperial
*Circa:* Prior to 1905

*Pattern:* Brunswick
*Circa:* 1870

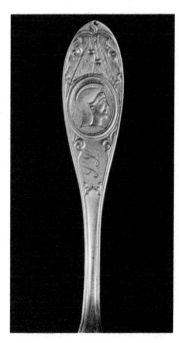

*Pattern:* Grecian
*Circa:* 1870

*Pattern:* Silver
*Circa:* 1870

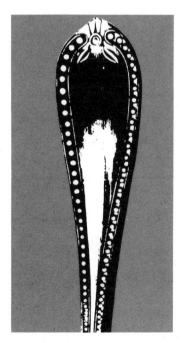

*Pattern:* Beaded
*Circa:* 1870

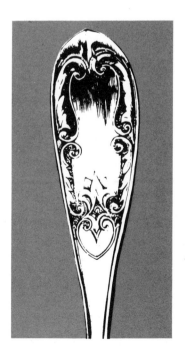

*Pattern:* American
*Circa:* 1870

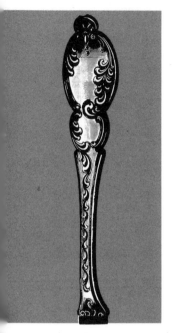

*Pattern:* Medallion
*Circa:* 1880

# Bridgeport Silver Co.

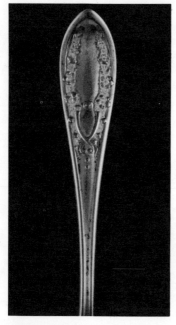

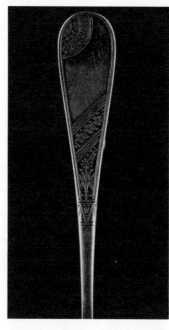

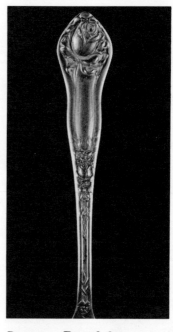

*Pattern:* Yorktown
*Circa:* 1913

*Pattern:* Angelo
*Circa:* 1883

*Pattern:* Rosedale
*Circa:* 1913

# Cambridge Silver Plate C S P

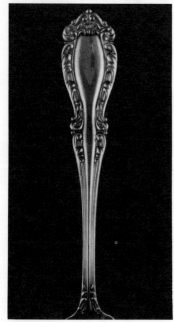

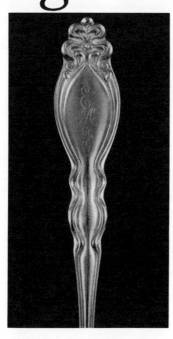

*Pattern:* Fleur de Lis
*Circa:* 1899

*Pattern:* Chalon
*Circa:* 1911

*Pattern:* Lady Grace
*Circa:* 1933

*Pattern:* Angelica
*Circa:* 1912

# Cambridge Silver Plate CSP

**Pattern:** Pelham
**Circa:** 1919

**Pattern:** Lady Claire
**Circa:** 1936

**Pattern:** Dunster
**Circa:** 1915

**Pattern:** Elmwood
**Circa:** 1916

**Pattern:** Newtown
**Circa:** 1915

**Pattern:** Lorraine
**Circa:** 1936

**Pattern:** American Beauty Rose
**Circa:** 1909

**Pattern:** Juliet
**Circa:** 1938

# Court Silver Plate

*Pattern:* Court
No Date — Special Contract Pattern

# Crosby Silver Plate Co.

*Pattern:* Crosby
No Date — Special Contract Pattern

# Crown Silver Plate Co.

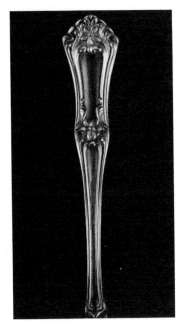

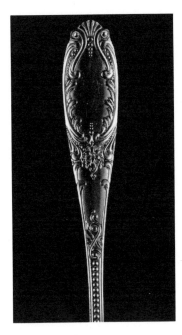

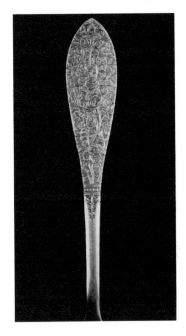

Pattern:  Arlington
Circa:  1919

Pattern:  Cuban
Circa:  1911

Pattern:  Valada
Circa:  1897

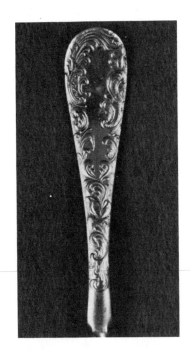

Pattern:  Florence
Circa:  1915

Pattern:  Tipped
Circa:  1911

Pattern:  Venice
Circa:  1881

# Cunningham Silver Plate

*Pattern:* Cunningham
*Circa:* 1950

# Derby Silver Co.

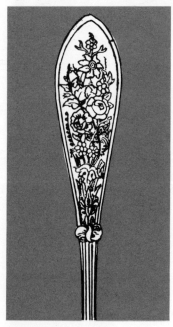

*Pattern:* Bouquet
*Circa:* 1875

*Pattern:* Olive
*Circa:* 1873

*Pattern:* Gothic
*Circa:* 1875

# Derby Silver Co.

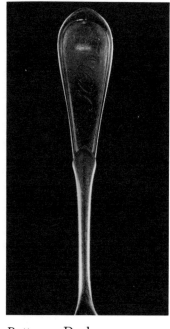

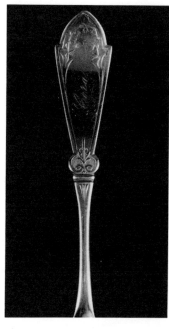

Pattern: Harvard
Circa: 1883

Pattern: Fiddle
Circa: 1883

Pattern: Derby
Circa: 1883

Pattern: Princess
Circa: 1875

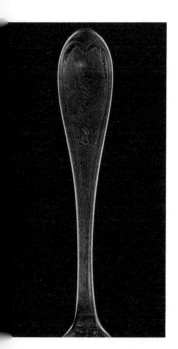

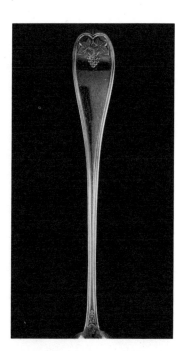

Pattern: Oval
Circa: 1875

Pattern: Grape
Circa: 1875

Pattern: Tipped
Circa: 1883

Pattern: Windsor
Circa: 1883

# Diamond Silver Co.

Pattern: Inauguration
Circa: 1948

# Embassy Silver Plate

Pattern: Magic Lily
Circa: 1955

Pattern: Bouquet
Circa: 1955

# Extra *Coin Silver* Plate

*Pattern:* Windsor
*Circa:* Prior to 1912

*Pattern:* Orient
*Circa:* 1906

*Pattern:* Leota
*Circa:* Prior to 1912

*Pattern:* Tipped
*Circa:* Prior to 1912

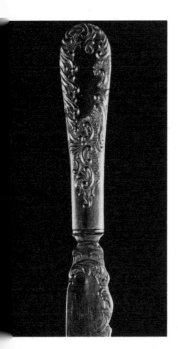

*attern:* Tacoma
*Circa:* Prior to 1912

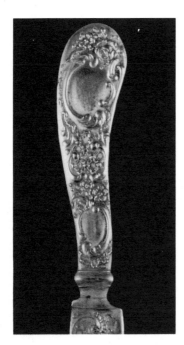

*Pattern:* Gladys
*Circa:* 1900

*Pattern:* Roxbury
*Circa:* 1913

*Pattern:* Shell
*Circa:* Prior to 1912

# *Fashion Silver Plate*

Pattern: Ascot
Circa: 1936

Pattern: Diplomat
Circa: 1941

Pattern: Lady Joan
Circa: 1931

Pattern: Lady Alice
Circa: 1936

Pattern: Debut
Circa: 1948

# Fenway Silver Plate

Pattern: Fenway
Circa: 1938

# Forbes Silver Co.

Pattern: Clovis
Circa: 1900

Pattern: Tipped
Circa: 1898

Pattern: Shell
Circa: 1898

# Fortune Silver Plate

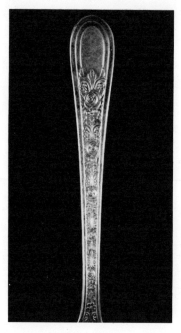

*Pattern:* Fortune
*Circa:* 1932

# Glastonbury Silver Co.

*Pattern:* Windsor
*Circa:* 1910

# Gorham

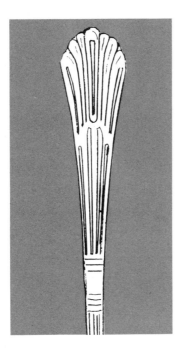

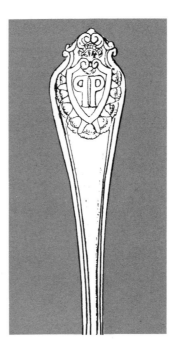

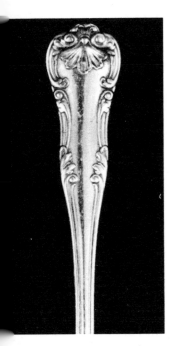

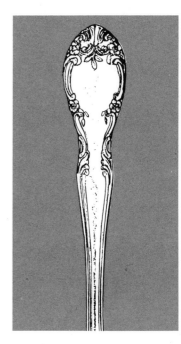

*Pattern:* Cavalier
*Circa:* 1938

*Pattern:* Invitation
*Circa:* 1940

*Pattern:* Remembrance
*Circa:* 1939

*Pattern:* Princess Louise
*Circa:* 1881

*Pattern:* Regent*
*Circa:* 1903

*Pattern:* Churchill
*Circa:* 1905

*Pattern:* Copley Plaza
*Circa:* 1910

*Pattern:* New Elegance
*Circa:* 1947

# Gorham

*Pattern:* Blackstone
*Circa:* 1906

*Pattern:* Winthrop
*Circa:* 1896

*Pattern:* Richmond
*Circa:* 1897

*Pattern:* Washington Irv
*Circa:* 1927

*Pattern:* Lady Caroline
*Circa:* 1939

*Pattern:* Bradford
*Circa:* 1925

*Pattern:* Westminster
*Circa:* 1924

*Pattern:* Stanhope
*Circa:* 1900

*Pattern:* Empire
*Circa:* 1906

*Pattern:* Commodore
*Circa:* 1917

*Pattern:* Shell
*Circa:* 1870

*Pattern:* Roman
*Circa:* 1866

*Pattern:* Kings
*Circa:* 1880-1935

*Pattern:* Beaumont
*Circa:* 1935

*Pattern:* Shelburne
*Circa:* 1914

*Pattern:* Providence
*Circa:* 1920

# Gorham

*Pattern:* Roslyn
*Circa:* 1915

*Pattern:* Caroline
*Circa:* 1935

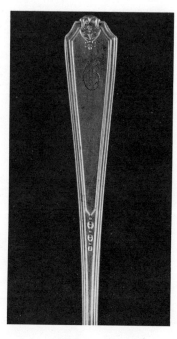

*Pattern:* Saxony
*Circa:* 1891

*Pattern:* Royal
*Circa:* 1888

*Pattern:* Vanity Fair
*Circa:* 1924

# Hall, Elton & Co.

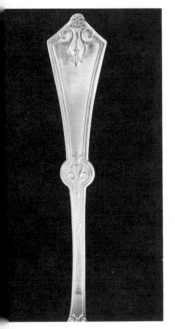

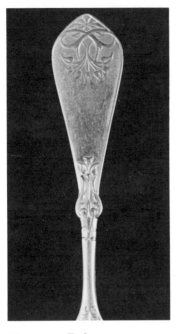

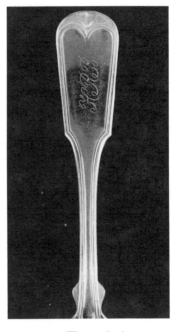

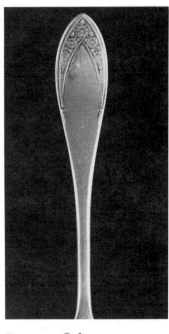

*Pattern:* Eastlake
*Circa:* 1875

*Pattern:* Palace
*Circa:* 1875

*Pattern:* Threaded
*Circa:* 1867

*Pattern:* Orleans
*Circa:* 1875

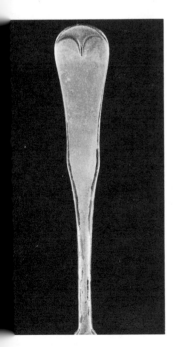

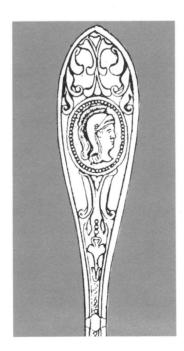

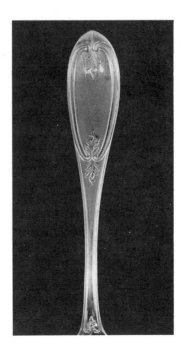

*Pattern:* Fiddle
*Circa:* 1867

*Pattern:* Medallion
*Circa:* 1867

*Pattern:* Olive
*Circa:* 1850

*Pattern:* Tipped
*Circa:* 1867

# Harmony House Plate

*Pattern:* Sharon
*Circa:* 1926

*Pattern:* Personality
*Circa:* 1938

*Pattern:* Danish Queen
*Circa:* 1944

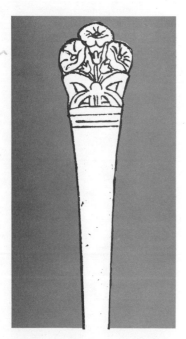

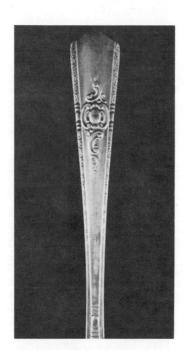

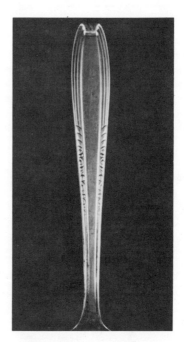

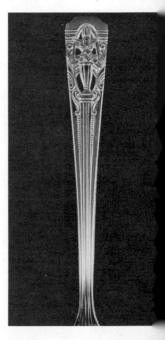

*Pattern:* Morning Glory
*Circa:* 1945

*Pattern:* Maytime
*Circa:* 1944

*Pattern:* Serenade
*Circa:* 1944

*Pattern:* Classic Filigre
*Circa:* 1945

# Heirloom Plate

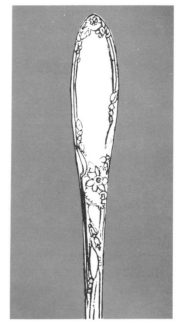

*Pattern:* Cardinal
*Circa:* 1920

*Pattern:* Longchamps
*Circa:* 1941

*Pattern:* Chateau
*Circa:* 1934

# Hibbard, Spencer, Bartlett & Co.

*Pattern:* Ivanhoe
*Circa:* 1911

*Pattern:* Heather
*Circa:* 1913

*Pattern:* Pilgrim
*Circa:* 1911

*Pattern:* Tipped
*Circa:* 1914

# Hibbard, Spencer, Bartlett & Co. OVB

*Pattern:* Windsor
*Circa:* 1914

*Pattern:* Shell
*Circa:* 1914

# Holmes & Edwards

*Pattern:* Tipped
*Circa:* 1883

*Pattern:* Marina
*Circa:* 1896

*Pattern:* Fiddle
*Circa:* 1885

*Pattern:* Windsor
*Circa:* 1890

# Holmes & Edwards

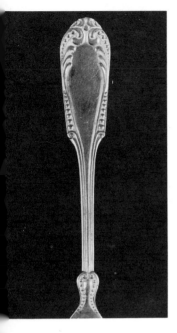

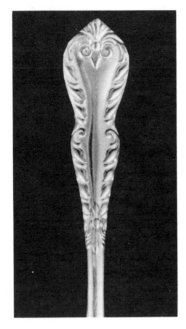

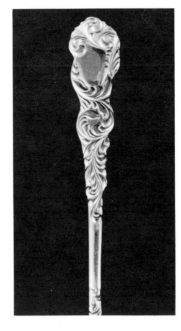

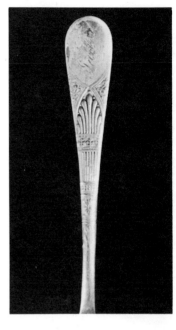

*Pattern:* Unique
*Circa:* 1897

*Pattern:* Delsart
*Circa:* 1893

*Pattern:* Rialto
*Circa:* 1894

*Pattern:* Leader
*Circa:* 1888

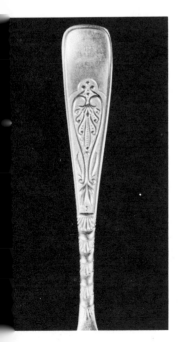

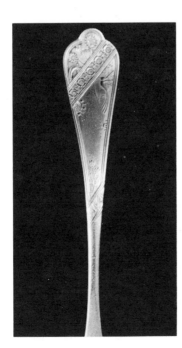

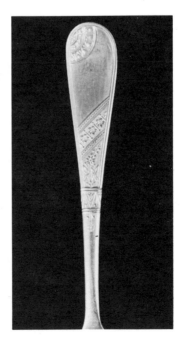

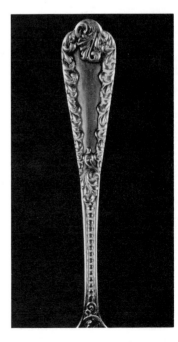

*Pattern:* Greek
*Circa:* 1889

*Pattern:* Eastlake
*Circa:* 1879

*Pattern:* Angelo
*Circa:* 1883

*Pattern:* Liberty
*Circa:* 1895

# Holmes & Edwards

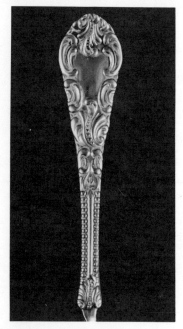

*Pattern:* Lincoln
*Circa:* 1895

*Pattern:* Threaded Hotel
*Circa:* 1904

*Pattern:* King
*Circa:* 1885

*Pattern:* Shell Thread
*Circa:* 1885

*Pattern:* Shell
*Circa:* 1894

*Pattern:* Nassau
*Circa:* 1899

*Pattern:* Jay Rose
*Circa:* 1892

*Pattern:* Waldorf
*Circa:* 1894

*attern:* Lafayette
*Circa:* 1908

*Pattern:* Dolly Madison
*Circa:* 1911

*Pattern:* Minnehaha
*Circa:* 1892

*Pattern:* Pearl
*Circa:* 1898

*attern:* Hiawatha
*Circa:* 1887

*Pattern:* Triumph
*Circa:* 1890

*Pattern:* Westfield
*Circa:* 1903

*Pattern:* Imperial
*Circa:* 1904

# Holmes & Edwards

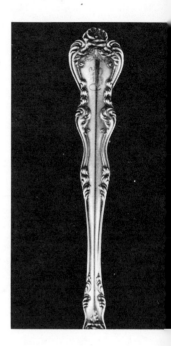

*Pattern:* Irving
*Circa:* 1895

*Pattern:* Happy Anniversary
*Circa:* 1960

*Pattern:* Anniversary Rose
*Circa:* 1962

*Pattern:* Orient
*Circa:* 1904

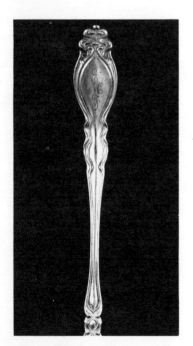

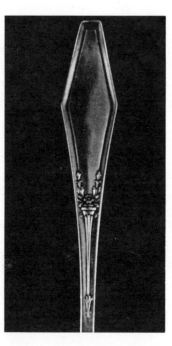

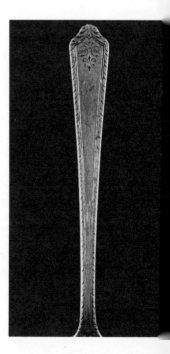

*Pattern:* Chatsworth
*Circa:* 1906

*Pattern:* Carolina
*Circa:* 1914

*Pattern:* Jamestown
*Circa:* 1916

*Pattern:* Pageant
*Circa:* 1927

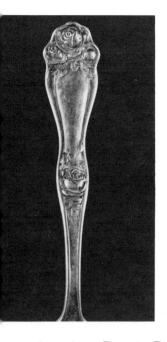

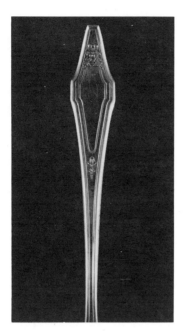

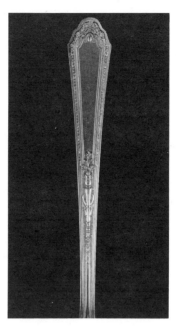

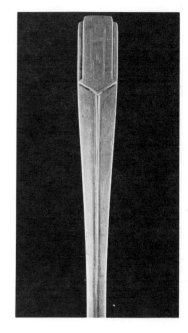

*ern:* American Beauty Rose  *Pattern:* Hostess  *Pattern:* Romance I  *Pattern:* Napoleon
*rca:* 1909  *Circa:* 1921  *Circa:* 1925  *Circa:* 1929

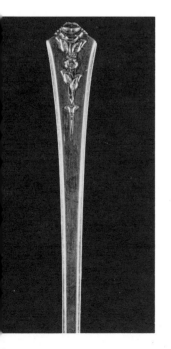

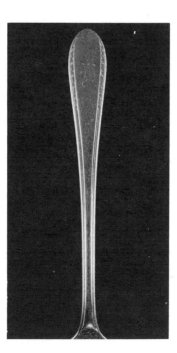

*attern:* Spring Garden  *Pattern:* First Lady  *Pattern:* Guest of Honor  *Pattern:* Century
*Circa:* 1949  *Circa:* 1935  *Circa:* 1935  *Circa:* 1935

# Holmes & Edwards

*Pattern:* Danish Princess
*Circa:* 1939

*Pattern:* Lovely Lady
*Circa:* 1937

*Pattern:* Youth
*Circa:* 1940

*Pattern:* Romance II
*Circa:* 1952

*Pattern:* Bright Future
*Circa:* 1954

*Pattern:* Newport
*Circa:* 1917

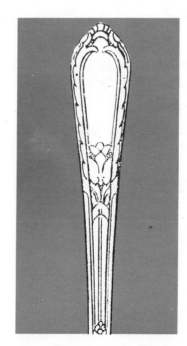

*Pattern:* Masterpiece
*Circa:* 1932

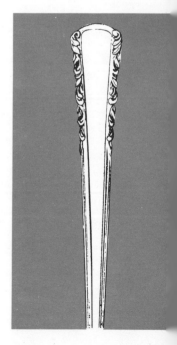

*Pattern:* May Queen
*Circa:* 1951

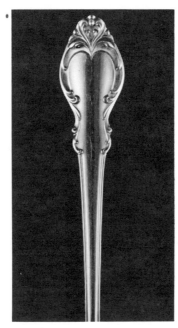

*Pattern:* Rhythmic
*Circa:* 1959

*Pattern:* Silver Fashion
*Circa:* 1957

*Pattern:* Woodsong
*Circa:* 1958

*Pattern:* Charm
*Circa:* 1929

*Pattern:* Warner
*Circa:* 1888

*Pattern:* Mayflower
*Circa:* 1888

*Pattern:* Fleur de Lis
*Circa:* 1899

# Holmes Booth & Haydens

*Pattern:* Japanese
*Circa:* 1879

*Pattern:* India
*Circa:* 1881

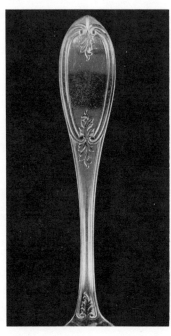

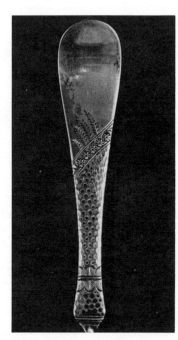

*Pattern:* Roman
*Circa:* 1884

*Pattern:* Olive
*Circa:* 1875

*Pattern:* Palace
*Circa:* 1879-1886

# Holmes & Tuttle Mfg. Co.

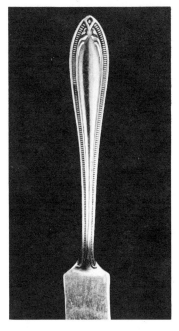

*Pattern:* LaSalle
*Circa:* 1921

*Pattern:* King George
*Circa:* 1921

*Pattern:* Bradford
*Circa:* 1921

*Pattern:* St. Paul
*Circa:* 1896

*Pattern:* Lorraine
*Circa:* 1900

# *International Silver Co.*

*Pattern:* Ambassador Hotel
*Circa:* 1952

*Pattern:* Falmouth
*Circa:* 1955

*Pattern:* Waldorf Astoria
*Circa:* Early 1950's

*Pattern:* TWA
*Circa:* 1958

# *King Edward Silver Plate*

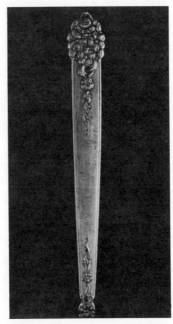

*Pattern:* Moss Rose
*Circa:* 1949

# Lady Beautiful Silverplate

*Pattern:* Martinique
*Circa:* 1935

# Lady Doris Silver Plate

*Pattern:* Lady Doris
*Circa:* 1929

# Lakeside Brand

*Pattern:* Tipped
*Circa:* 1895

*Pattern:* Shell
*Circa:* 1895

*Pattern:* Helena
*Circa:* 1914

*Pattern:* Vineyard
*Circa:* 1906

*Pattern:* Holly
*Circa:* 1907

*Pattern:* Windsor
*Circa:* 1895

*Pattern:* Marseilles
*Circa:* 1906

*Pattern:* Lakewood
*Circa:* 1914

# Landers, Frary & Clark

*Pattern:* Windsor
*Circa:* 1890

# Lynbrook Plate

*Pattern:* Lynbrook
*Circa:* 1936

# Madrid Silver Plate

*Pattern:* Madrid
*Circa:* 1932

# Marion Silver Plate

*Pattern:* Camden
*Circa:* 1929

*Pattern:* Jewell
*Circa:* 1916

# J. O. Mead & Sons

*Pattern:* Olive
*Circa:* 1850

# Melody Silver Plate

*Pattern:* Melody
*Circa:* 1954

# Meriden Britannia Co.

*Pattern:* St. Charles
*Circa:* 1855

*Pattern:* Monarch
*Circa:* 1889

*Pattern:* Westfield
*Circa:* 1903

# Meriden Silver Plate Co.

*Pattern:* Delight
*Circa:* 1950

*Pattern:* Beloved
*Circa:* 1960

# Montgomery Ward and Co.

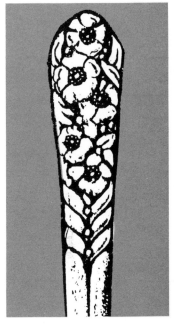

| Pattern: Hand Engraved | Pattern: Mignon | Pattern: Ward Modern | Pattern: Ward Bouquet |
| Circa: 1892 | Circa: 1907 | Circa: 1936 | Circa: 1936 |

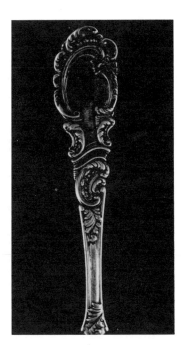

*Pattern:* Hand Engraved  *Circa:* 1892

*Pattern:* Mignon  *Circa:* 1907

*Pattern:* Ward Modern  *Circa:* 1936

*Pattern:* Ward Bouquet  *Circa:* 1936

*Pattern:* Chicago  *Circa:* 1892

*Pattern:* Myrtle  *Circa:* 1896

*Pattern:* Mistletoe  *Circa:* 1907

*Pattern:* Norma  *Circa:* 1907

# Montgomery Ward and Co.

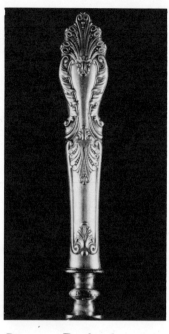

*Pattern:* Argos
*Circa:* 1907

*Pattern:* Marquis
*Circa:* 1907

*Pattern:* Raphael
*Circa:* 1907

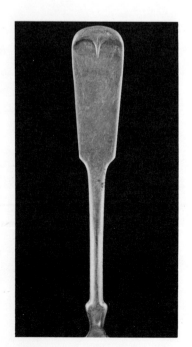

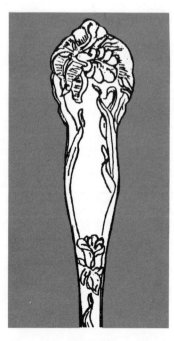

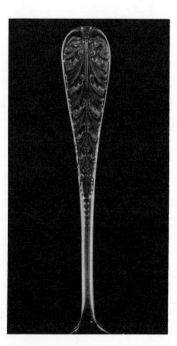

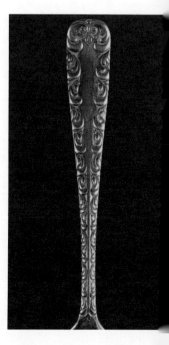

*Pattern:* Tipped
*Circa:* 1892

*Pattern:* Peerless
*Circa:* 1907

*Pattern:* Acanthus
*Circa:* 1886

*Pattern:* Majestic
*Circa:* 1896

# Montgomery Ward and Co.

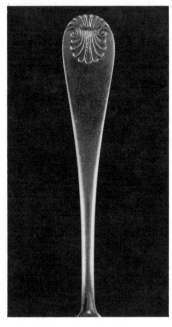

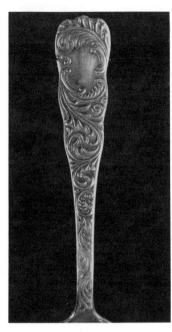

*Pattern:* Shell
*Circa:* 1896

*Pattern:* Monarch
*Circa:* 1897

# Mulford, Wendell & Co.

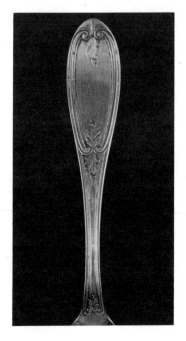

*Pattern:* Olive
*Circa:* 1855

# National Silver Co.

*Pattern:* Astrid
*Circa:* 1945

*Pattern:* Cavalcade
*Circa:* 1946

*Pattern:* Lady Grace
*Circa:* 1933

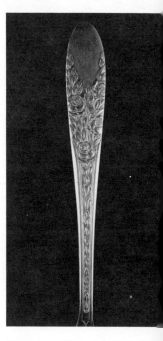

*Pattern:* Rose & Leaf
*Circa:* 1937

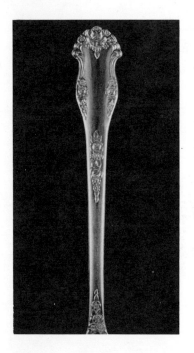

*Pattern:* Holiday
*Circa:* 1951

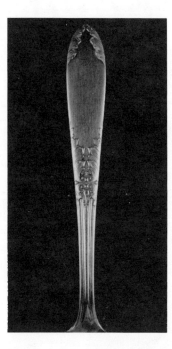

*Pattern:* King Edward
*Circa:* 1951

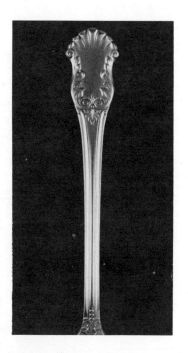

*Pattern:* Concerto
*Circa:* 1944

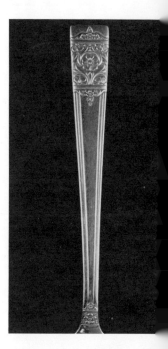

*Pattern:* Inauguration
*Circa:* 1948

# Newport Silver Plate

*Pattern:* Newport
*Circa:* 1946

# Niagara Silver Co.

*Pattern:* Vernon
*Circa:* 1900

*Pattern:* Iroquois
*Circa:* 1900

# Niagara Silver Co.

*Pattern:* Tacoma
*Circa:* 1900

*Pattern:* Alberta
*Circa:* 1900

*Pattern:* Shell
*Circa:* 1900

*Pattern:* Gladys
*Circa:* 1900

*Pattern:* Tipped
*Circa:* 1900

*Pattern:* Windsor
*Circa:* 1900

*Pattern:* Cinderella
*Circa:* 1900

# N. F. Silver Co.

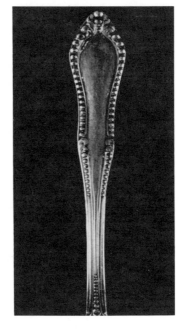

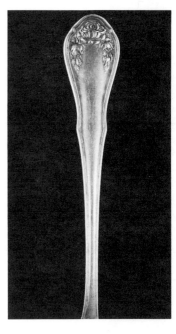

Pattern: Essex
Circa: 1900

Pattern: Adams
Circa: 1905

Pattern: Beaded
Circa: 1896

Pattern: Bridal Rose
Circa: 1913

# Nobility Plate

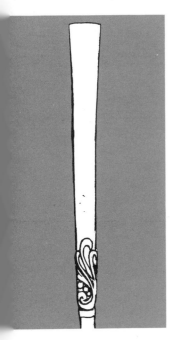

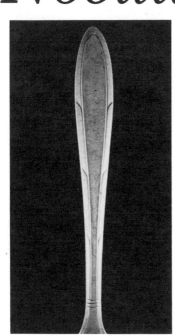

Pattern: Windsong
Circa: 1939

Pattern: Reverie
Circa: 1939

Pattern: Caprice
Circa: 1939

Pattern: Royal Rose
Circa: 1939

# Old Company Plate

Pattern: Signature,
Circa: 1950

Pattern: Radiance
Circa: 1958

# Oneida Community

Pattern: Fiddle
Circa: 1900

Pattern: Tipped
Circa: 1900

Pattern: Careta
Circa: 1902

Pattern: Fleur de Lis
Circa: 1904

# Oneida Community

*tern:* Windsor
*irca:* 1900

*Pattern:* Berkley Square
*Circa:* 1935

*Pattern:* Classic*
*Circa:* 1911

*Pattern:* Avalon
*Circa:* 1903

*tern:* Sheraton
*irca:* 1913

*Pattern:* Grosvenor
*Circa:* 1927

*Pattern:* Georgian
*Circa:* 1913

*Pattern:* Louis XVI
*Circa:* 1910

# Oneida Community

*Pattern:* Silver Flowers
*Circa:* 1960

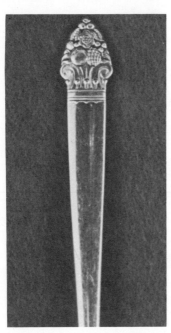

*Pattern:* King Cedric
*Circa:* 1937

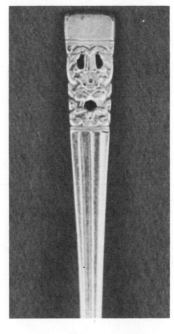

*Pattern:* Coronation
*Circa:* 1939

*Pattern:* Adam
*Circa:* 1927

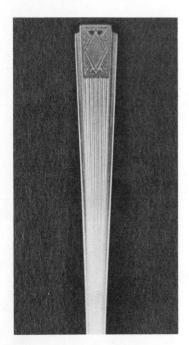

*Pattern:* Noblesse
*Circa:* 1933

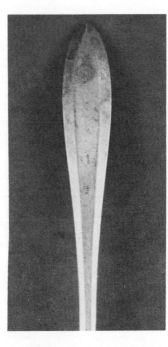

*Pattern:* Patrician
*Circa:* 1927

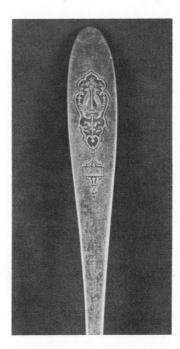

*Pattern:* Bird of Paradise
*Circa:* 1933

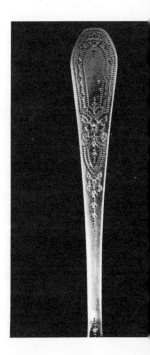

*Pattern:* Paul Revere
*Circa:* 1927

*ttern:* Deauville
*Circa:* 1929

*Pattern:* Hampden Court
*Circa:* 1926

*Pattern:* Vernon
*Circa:* 1927

*Pattern:* Forever
*Circa:* 1939

*tern:* Milady
*irca:* 1940

*Pattern:* Ballad
*Circa:* 1953

*Pattern:* White Orchid
*Circa:* 1953

*Pattern:* Silver Artistry
*Circa:* 1970

# Oneida Community

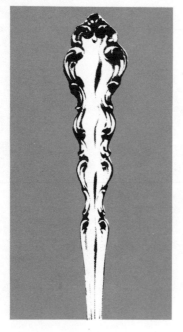 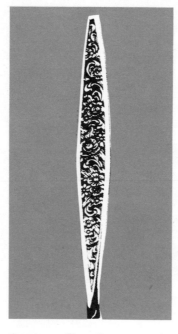 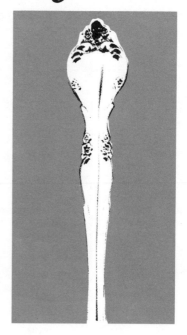

*Pattern:* Modern Baroque
*Circa:* 1970

*Pattern:* Tangler
*Circa:* 1970

*Pattern:* Affection
*Circa:* 1970

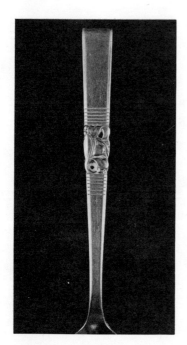  

*Pattern:* Morning Star
*Circa:* 1948

*Pattern:* Evening Star
*Circa:* 1950

*Pattern:* Patrician
*Circa:* 1977

*Pattern:* Morning Rose
*Circa:* 1970

*Pattern:* Royal Grandeur
*Circa:* 1977

*Pattern:* Royal Lace
*Circa:* 1977

*Pattern:* South Seas
*Circa:* 1955

*Pattern:* Twilight
*Circa:* 1956

# *Oneida Community-Capitol Plate*

Pattern: Winthrop
Circa: 1929

Pattern: Mary Lee
Circa: 1932

# *Oneida Community-Duro Plate*

Pattern: Beverly
Circa: 1922

# *Oneida Community-Par Plate*

*Pattern:* Primrose
*Circa:* 1917

*Pattern:* Vernon
*Circa:* 1927

*Pattern:* Bridal Wreath
*Circa:* 1927

*Pattern:* Ardsley
*Circa:* 1927

*Pattern:* Clarion
*Circa:* 1931

# Oneida Community-Reliance Plate

*Pattern:* Kenwood
*Circa:* 1913

*Pattern:* Wildwood
*Circa:* 1908

*Pattern:* La Rose
*Circa:* 1917

*Pattern:* Exeter
*Circa:* 1917

# Oneida Community-Tudor Plate

*Pattern:* Queen Bess
*Circa:* 1929

*Pattern:* Skyline
*Circa:* 1936

*Pattern:* Mary Stuart*
*Circa:* 1927

*Pattern:* Winsome
*Circa:* 1960

# Oneida Community-Tudor Plate

*Pattern:* Sweetbriar
*Circa:* 1948

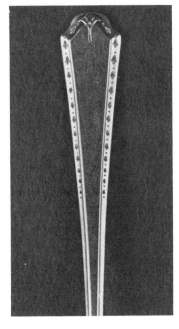

*Pattern:* Baronet
*Circa:* 1922

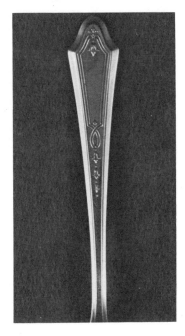

*Pattern:* Duchess
*Circa:* 1922

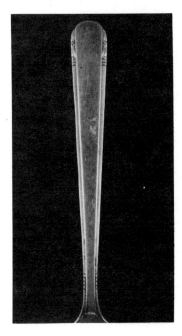

*Pattern:* Elaine
*Circa:* 1924

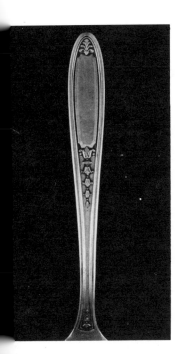

*Pattern:* Enchantment
*Circa:* 1929

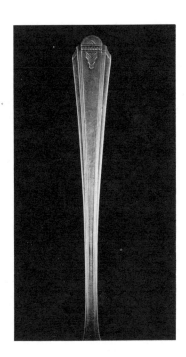

*Pattern:* Barbara
*Circa:* 1931

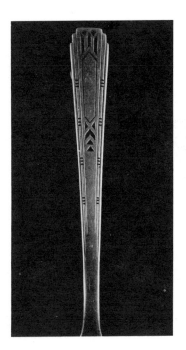

*Pattern:* Friendship
*Circa:* 1932

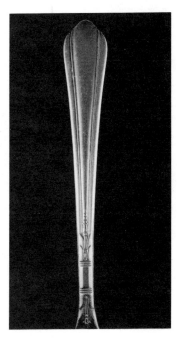

*Pattern:* June
*Circa:* 1935

# *Oneida Community-Tudor Plate*

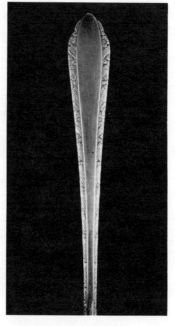

*Pattern:* Madelon
*Circa:* 1935

*Pattern:* Bridal Wreath
*Circa:* 1950

*Pattern:* Together
*Circa:* 1956

*Pattern:* Fantasy
*Circa:* 1941

*Pattern:* Queen Bess II
*Circa:* 1946

# Oxford Silver Co.

Pattern: Garland
Circa: 1910

Pattern: Narcissus
Circa: 1912

Pattern: Careta
Circa: 1902

Pattern: Windsor
Circa: Prior to 1912

# Pairpoint Mfg. Co.

Pattern: Laurion
Circa: 1887

Pattern: Marseilles
Circa: 1906

Pattern: Arlington
Circa: 1896

Pattern: Croyden
Circa: 1887

# Pairpoint Mfg. Co.

*Pattern:* Dresden
*Circa:* 1891

*Pattern:* Erminie
*Circa:* 1889

# Paragon Silver Plate

*Pattern:* Royal Oak
*Circa:* 1906

*Pattern:* Fleur de Lis
*Circa:* 1899

*Pattern:* Oxford
*Circa:* 1901

*Pattern:* Iris
*Circa:* 1902

# Paragon Silver Plate

*Pattern:* Sweet Pea
*Circa:* 1908

*Pattern:* Colonial
*Circa:* 1906

*Pattern:* Rose
*Circa:* 1905

*Pattern:* Angelica
*Circa:* 1912

*Pattern:* Chalon
*Circa:* 1906

*Pattern:* Muscatel
*Circa:* 1910

*Pattern:* Tipped
*Circa:* 1907

*Pattern:* Shell
*Circa:* 1907

# Plymouth Silver Plate

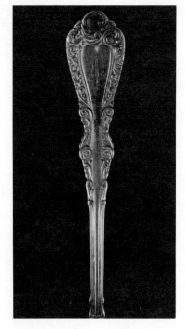

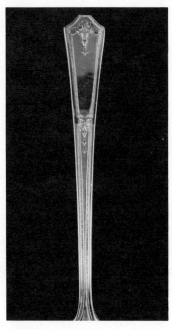

*Pattern:* Plymouth
*Circa:* 1897

*Pattern:* Jewel
*Circa:* 1938

*Pattern:* Bouquet
*Circa:* 1929

# Prestige Plate

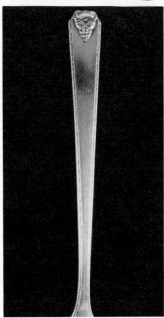

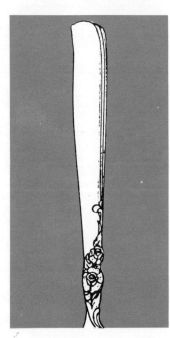

*Pattern:* Bordeau
*Circa:* 1946

*Pattern:* Gay Adventure
*Circa:* 1946

# Puritan Silver Company

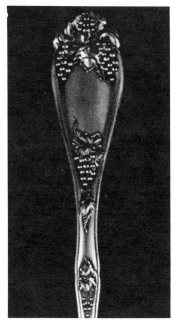

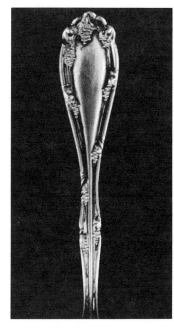

*Pattern:* Puritan Grape I
*Circa:* 1913

*Pattern:* Puritan Grape II
*Circa:* 1914

# Reed & Barton

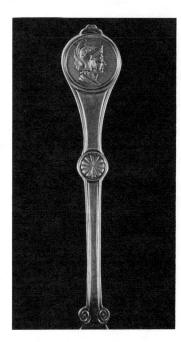

*Pattern:* Tipped
*Circa:* 1870

*Pattern:* Fiddle
*Circa:* 1887

*Pattern:* Palace
*Circa:* 1885

*Pattern:* Medallion
*Circa:* 1868

# Reed & Barton

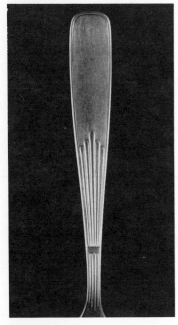

*Pattern:* Vendome
*Circa:* 1884

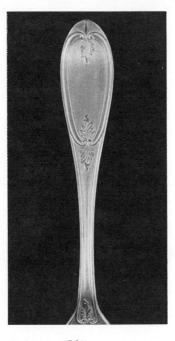

*Pattern:* Olive
*Circa:* Prior to 1868

*Pattern:* Windsor
*Circa:* 1880

*Pattern:* Tavern
*Circa:* 1942

*Pattern:* Threaded
*Circa:* Prior to 1868

*Pattern:* Russian
*Circa:* 1883

*Pattern:* Gem
*Circa:* 1871

*Pattern:* Unique
*Circa:* 1879

*Pattern:* Pearl
*Circa:* 1878

*Pattern:* Pearl (Variation)
*Circa:* 1878

*Pattern:* Parisian
*Circa:* 1883

*Pattern:* Cashmere
*Circa:* 1884

*Pattern:* Orient
*Circa:* 1879

*Pattern:* Le Louvre
*Circa:* 1888

*Pattern:* Rembrant
*Circa:* 1935

*Pattern:* Dresden Rose
*Circa:* 1953

# Reed & Barton

*Pattern:* Italian
*Circa:* 1885

*Pattern:* Clarendon
*Circa:* 1890

*Pattern:* Alden
*Circa:* 1907

*Pattern:* Normandy
*Circa:* 1925

*Pattern:* Clovelly
*Circa:* 1920

*Pattern:* La Salle
*Circa:* 1928

*Pattern:* Renaissance
*Circa:* 1886

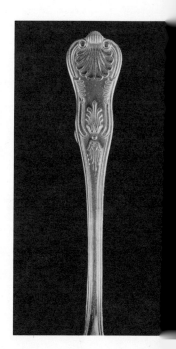

*Pattern:* Kings
*Circa:* 1890

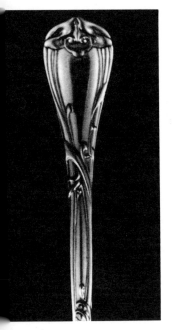

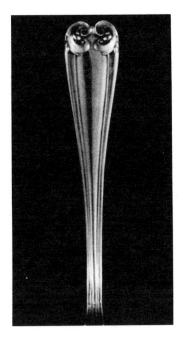

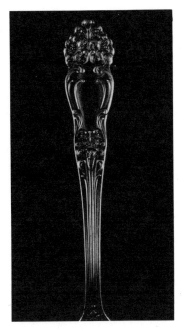

*Pattern:* Modern Art
*Circa:* 1904

*Pattern:* Belmont
*Circa:* 1906

*Pattern:* Tiger Lily
*Circa:* 1901

*Pattern:* Sierra
*Circa:* 1914

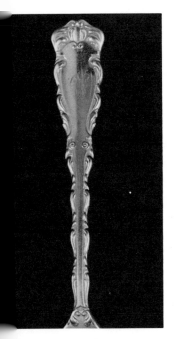

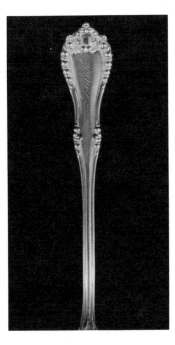

*Pattern:* Rex
*Circa:* 1894

*Pattern:* Carlton
*Circa:* 1896

*Pattern:* Louis XVI
*Circa:* 1926

*Pattern:* Commonwealth
*Circa:* 1939

# Reed & Barton

*Pattern:* New Emperor
*Circa:* 1970

*Pattern:* Wisteria
*Circa:* 1970

*Pattern:* Festivity
*Circa:* 1970

*Pattern:* English Crow
*Circa:* 1970

*Pattern:* Pompein
*Circa:* 1930

*Pattern:* Old London
*Circa:* 1936

*Pattern:* King Francis
*Circa:* 1976

*Pattern:* 1776 Plain
*Circa:* 1976

*Pattern:* 1776 Hammered    *Pattern:* Gentry
*Circa:* 1976             *Circa:* 1976

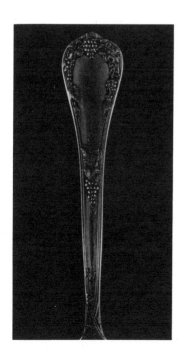

*Pattern:* Sheffield    *Pattern:* Corsican    *Pattern:* Plain
*Circa:* 1922       *Circa:* 1926      *Circa:* Prior to 1868

# Rockford Silver Plate Co.

*Pattern:* Erminie
*Circa:* 1900

*Pattern:* Lancaster
*Circa:* 1908

*Pattern:* State
*Circa:* 1915

*Pattern:* Puritan Engra

*Pattern:* Fair Oaks
*Circa:* 1920

*Pattern:* Puritan
*Circa:* 1920

*Pattern:* Hawthorn
*Circa:* 1915

*Pattern:* Clayborne
*Circa:* 1929

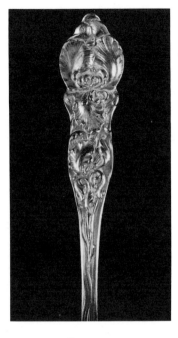

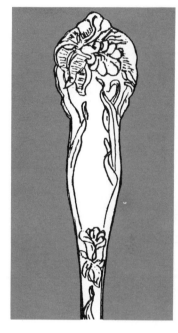

*Pattern:* Whittier
*Circa:* 1915

*Pattern:* Rose
*Circa:* 1915

*Pattern:* Louvre
*Circa:* 1905

*Pattern:* Daffodil
*Circa:* 1907

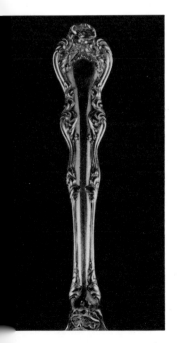

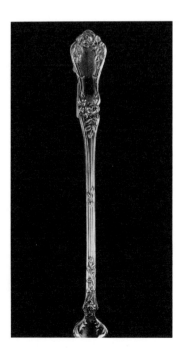

*Pattern:* Venice
*Circa:* 1900

*Pattern:* Rosemary
*Circa:* 1906

*Pattern:* Grape
*Circa:* 1907

*Pattern:* Gloria
*Circa:* 1906

# 1847 Rogers Bros.

*Pattern:* Plain
*Circa:* 1862

*Pattern:* Windsor
*Circa:* 1862

*Pattern:* Ruby
*Circa:* 1892

*Pattern:* Coral
*Circa:* 1892

*Pattern:* Stockbridge
*Circa:* 1892

*Pattern:* Vassar
*Circa:* 1892

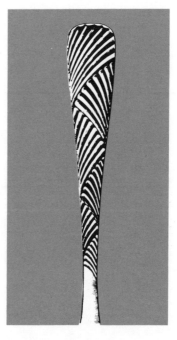

*Pattern:* Brunswick
*Circa:* 1892

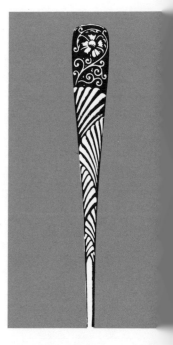

*Pattern:* Daisy
*Circa:* 1892

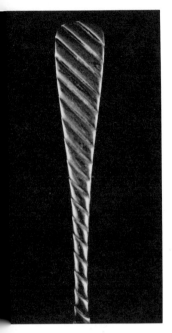

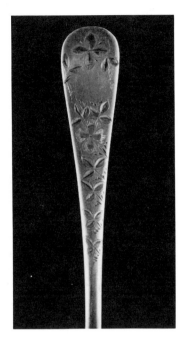

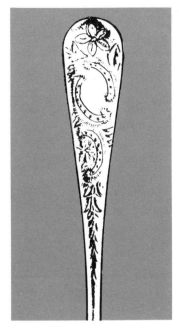

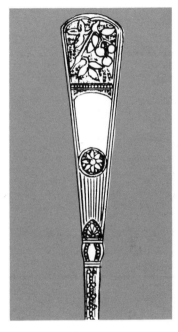

*Pattern:* San Diego
*Circa:* 1884

*Pattern:* Linden
*Circa:* 1891

*Pattern:* Diana
*Circa:* 1894

*Pattern:* Nevada
*Circa:* 1881

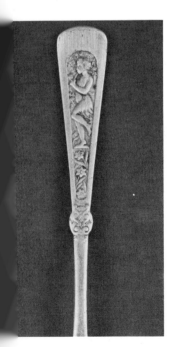

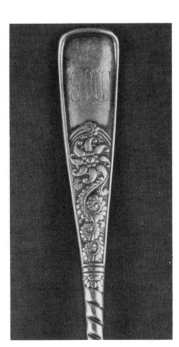

*Pattern:* Arcadian
*Circa:* 1884

*Pattern:* Assyrian
*Circa:* 1887

*Pattern:* Pearl
*Circa:* 1892

*Pattern:* Lenox II
*Circa:* 1892

# 1847 Rogers Bros.

*Pattern:* Gem
*Circa:* 1892

*Pattern:* Tolland
*Circa:* 1892

*Pattern:* Columbia
*Circa:* 1893

*Pattern:* Savoy
*Circa:* 1893

*Pattern:* Moselle
*Circa:* 1891

*Pattern:* Lily
*Circa:* 1874

*Pattern:* Saratoga
*Circa:* 1881

*Pattern:* Lorraine
*Circa:* 1892

*Pattern:* Colonade I
*Circa:* 1892

*Pattern:* Lenox I
*Circa:* 1892

*Pattern:* Delmonico II
*Circa:* 1892

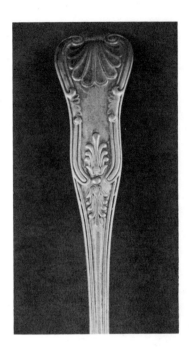

*Pattern:* Kings
*Circa:* 1888

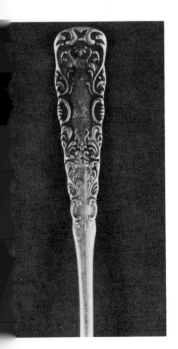

*Pattern:* Portland
*Circa:* 1891

*Pattern:* Louis XV
*Circa:* 1891

*Pattern:* French Oval
*Circa:* 1852

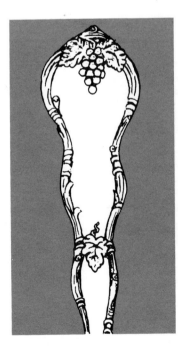

*Pattern:* Concord
*Circa:* 1904

# 1847 Rogers Bros.

*Pattern:* Milam
*Circa:* 1907

*Pattern:* Vesta
*Circa:* 1895

*Pattern:* Berkshire
*Circa:* 1895

*Pattern:* Plazza
*Circa:* 1892

*Pattern:* Florida
*Circa:* 1892

*Pattern:* Shrewsbury
*Circa:* 1892

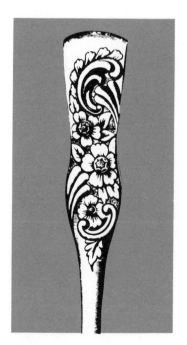

*Pattern:* Kensington
*Circa:* 1892

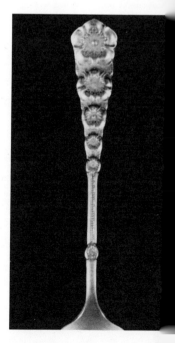

*Pattern:* Primrose
*Circa:* 1895

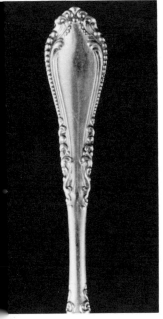

*Pattern:* Norfolk
*Circa:* 1900

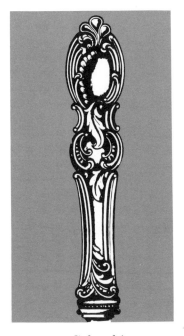

*Pattern:* Columbian
*Circa:* 1892

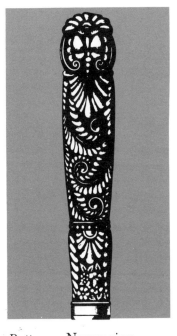

*Pattern:* Norwegian
*Circa:* 1892

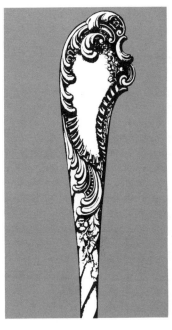

*Pattern:* Majestic
*Circa:* 1892

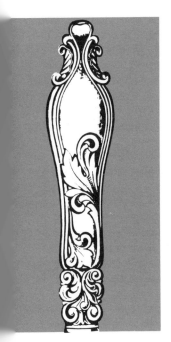

*Pattern:* Grecian
*Circa:* 1892

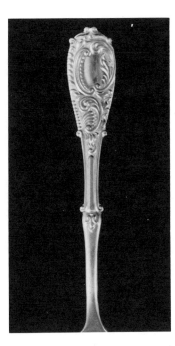

*Pattern:* Moline
*Circa:* 1893

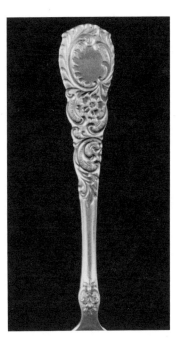

*Pattern:* Harvard
*Circa:* 1892

*Pattern:* Hoffman II
*Circa:* 1892

# 1847 Rogers Bros.

*Pattern:* Star
*Circa:* 1892

*Pattern:* Clover
*Circa:* 1892

*Pattern:* Hoffman I
*Circa:* 1891

*Pattern:* Swiss
*Circa:* 1892

*Pattern:* French
*Circa:* 1892

*Pattern:* Delmonico I
*Circa:* 1892

*Pattern:* Ivy
*Circa:* 1870

*Pattern:* Sabre Handle
*Circa:* 1938

*Pattern:* Colonade II
*Circa:* 1892

*Pattern:* Florentine IV
*Circa:* 1892

*Pattern:* Royal
*Circa:* 1892

*Pattern:* Laurel
*Circa:* 1878

*Pattern:* Lorne
*Circa:* 1878

*Pattern:* Florentine II
*Circa:* 1892

*Pattern:* Romanesque
*Circa:* 1898

*Pattern:* Roman
*Circa:* 1865

# 1847 Rogers Bros.

*Pattern:* Princess
*Circa:* 1874

*Pattern:* Florentine III
*Circa:* 1892

*Pattern:* Venetian
*Circa:* 1892

*Pattern:* Shell Tip
*Circa:* 1855

*Pattern:* Gothic*
*Circa:* 1862

*Pattern:* Berkeley
*Circa:* 1892

*Pattern:* Cordova
*Circa:* 1892

*Pattern:* Horn of Plen
*Circa:* 1938

*Pattern:* Yale
*Circa:* 1892

*Pattern:* 1890
*Circa:* 1892

*Pattern:* Floral
*Circa:* 1892

*Pattern:* Forget Me Not
*Circa:* 1907

*Pattern:* Sylvia
*Circa:* 1934

*Pattern:* American Beauty Rose
*Circa:* 1909

*Pattern:* Armenian
*Circa:* 1886

*Pattern:* Flanders
*Circa:* 1907

# 1847 Rogers Bros.

Pattern: Pistol Handle
Circa: 1938

Pattern: Olive
Circa: 1848

Pattern: Fiddle
Circa: 1850

Pattern: Threaded
Circa: 1847

Pattern: Silver
Circa: 1850

Pattern: Tuscan
Circa: 1862

Pattern: Oval
Circa: 1862

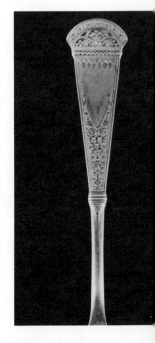

Pattern: Imperial
Circa: 1880

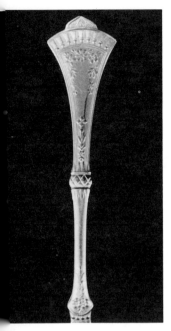

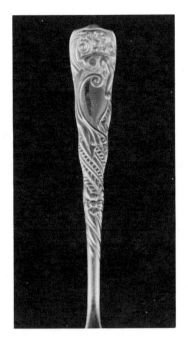

*Pattern:* Crown   *Pattern:* Siren   *Pattern:* Etruscan   *Pattern:* Assyrian Head
*Circa:* 1885   *Circa:* 1891   *Circa:* 1891   *Circa:* 1886

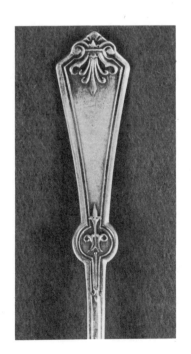

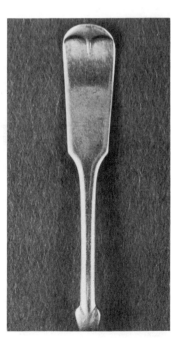

*Pattern:* Dundee   *Pattern:* Shell   *Pattern:* Persian   *Pattern:* Tipped
*Circa:* 1886   *Circa:* 1860   *Circa:* 1871   *Circa:* 1847

# 1847 Rogers Bros.

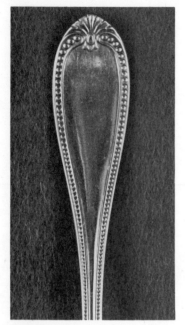

*Pattern:* Beaded
*Circa:* 1855

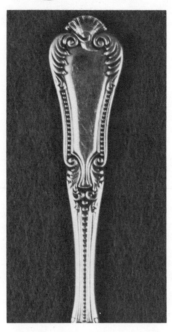

*Pattern:* Lotus
*Circa:* 1895

*Pattern:* Priscilla
*Circa:* 1900

*Pattern:* Scythian
*Circa:* 1892

*Pattern:* Continental
*Circa:* 1914

*Pattern:* Newport
*Circa:* 1880

*Pattern:* Embossed
*Circa:* 1882

*Pattern:* Avon
*Circa:* 1901

*Pattern:* Vintage
*Circa:* 1904

*Pattern:* Charter Oak
*Circa:* 1906

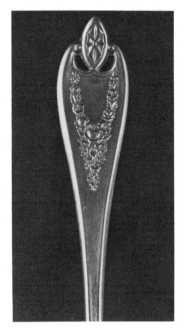

*Pattern:* Old Colony
*Circa:* 1911

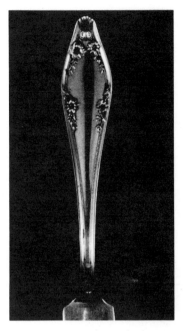

*Pattern:* Mayfair
*Circa:* 1910

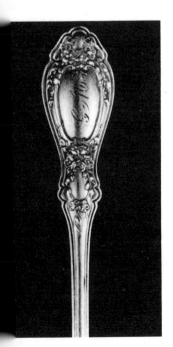

*Pattern:* Sharon
*Circa:* 1910

*Pattern:* Cromwell
*Circa:* 1912

*Pattern:* Heraldic
*Circa:* 1916

*Pattern:* Salem
*Circa:* 1911

# 1847 Rogers Bros.

*Pattern:* Queen Ann
*Circa:* 1917

*Pattern:* Faneuil
*Circa:* 1908

*Pattern:* Louvain
*Circa:* 1918

*Pattern:* Ambassador
*Circa:* 1920

*Pattern:* Anniversary
*Circa:* 1922

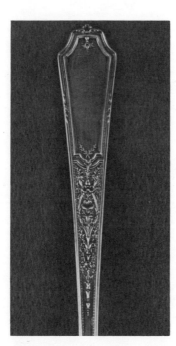

*Pattern:* Ancestral
*Circa:* 1924

*Pattern:* Silhouette
*Circa:* 1929

*Pattern:* Adoration
*Circa:* 1939

*Pattern:* Argosy
*Circa:* 1926

*Pattern:* Legacy
*Circa:* 1928

*Pattern:* Marquise
*Circa:* 1932

*Pattern:* First Love
*Circa:* 1937

*Pattern:* Her Majesty
*Circa:* 1931

*Pattern:* Lovelace
*Circa:* 1936

*Pattern:* Eternally Yours
*Circa:* 1941

*Pattern:* Reflection
*Circa:* 1959

# 1847 Rogers Bros.

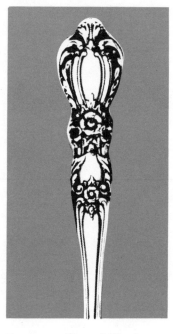

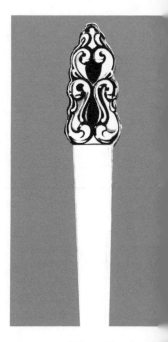

*Pattern:* Magic Rose
*Circa:* 1963

*Pattern:* Garland
*Circa:* 1965

*Pattern:* Grand Heritage
*Circa:* 1968

*Pattern:* King Frederik
*Circa:* 1969

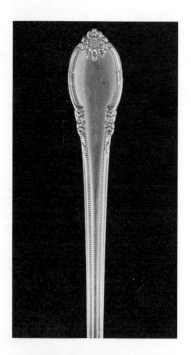

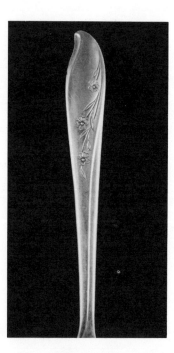

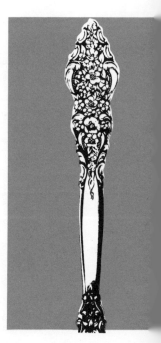

*Pattern:* Remembrance
*Circa:* 1948

*Pattern:* Springtime
*Circa:* 1957

*Pattern:* Silver Lace
*Circa:* 1968

*Pattern:* Silver Renaissa
*Circa:* 1971

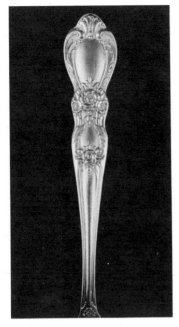

*Pattern:* Heritage
*Circa:* 1953

*Pattern:* Flair
*Circa:* 1956

*Pattern:* Leilani
*Circa:* 1961

*Pattern:* Esperanto
*Circa:* 1967

*Pattern:* Daffodil
*Circa:* 1950

*Pattern:* Love
*Circa:* 1970

# 1881 Rogers

*Pattern:* Meadowbrook
*Circa:* 1939

*Pattern:* Delmar
*Circa:* 1949

*Pattern:* Grecian
*Circa:* 1917

*Pattern:* Leyland
*Circa:* 1917

*Pattern:* Chippendale
*Circa:* 1919

*Pattern:* Cheshire
*Circa:* 1925

*Pattern:* Tipped
*Circa:* 1912

*Pattern:* Linden
*Circa:* 1912

*Pattern:* Greylock
*Circa:* 1910

*Pattern:* Briar Rose
*Circa:* 1910

*Pattern:* Justice
*Circa:* 1916

*Pattern:* Plymouth
*Circa:* 1917

*Pattern:* Proposal
*Circa:* 1954

*Pattern:* Lilac Time
*Circa:* 1957

*Pattern:* Chevron
*Circa:* 1931

*Pattern:* Ardsley
*Circa:* 1912

# 1881 Rogers

*Pattern:* Scotia
*Circa:* 1915

*Pattern:* Coronet
*Circa:* 1926

*Pattern:* Windsor
*Circa:* Prior to 1912

*Pattern:* Shell
*Circa:* Prior to 1912

*Pattern:* Empress
*Circa:* 1908

*Pattern:* Lavigne
*Circa:* 1917

*Pattern:* Janet
*Circa:* 1936

*Pattern:* Surf Club
*Circa:* 1938

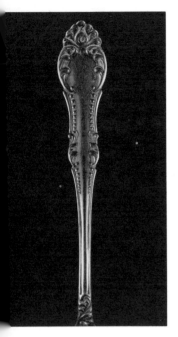

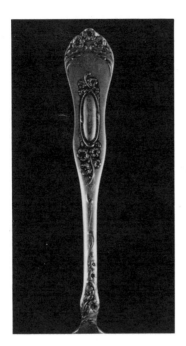

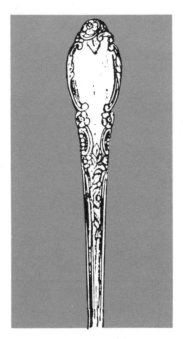

*Pattern:* Carlton
*Circa:* 1898

*Pattern:* Beverly
*Circa:* 1909

*Pattern:* Enchantment
*Circa:* 1952

*Pattern:* First Colony
*Circa:* 1977

*Pattern:* Victorian Classic
*Circa:* 1977

*Pattern:* Godetia
*Circa:* 1912

*Pattern:* Flirtation
*Circa:* 1977

*Pattern:* Baroque Rose
*Circa:* 1977

# 1881 Rogers

Pattern: Faun
Circa: 1930

Pattern: Tempo
Circa: 1930

Pattern: Capri
Circa: 1948

Pattern: Plantation
Circa: 1948

Pattern: Elmore
Circa: 1905

# ⚓ *Rogers* ⚓

*Pattern:* Acme
*Circa:* 1879

*Pattern:* Regent
*Circa:* 1878

*Pattern:* Roman
*Circa:* 1879

*Pattern:* Hartford
*Circa:* 1879

*Pattern:* Crown
*Circa:* 1879

*Pattern:* Persian
*Circa:* 1879

*Pattern:* Fiddle
*Circa:* 1879

*Pattern:* Plain
*Circa:* 1879

# ⚓Rogers⚓

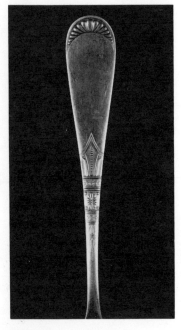

*Pattern:* Daisey
*Circa:* 1886

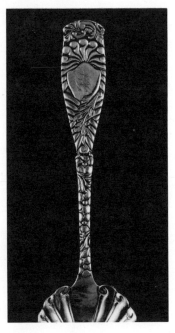

*Pattern:* Scroll
*Circa:* 1890

*Pattern:* Windsor
*Circa:* 1879

*Pattern:* Tipped
*Circa:* 1879

*Pattern:* Opal
*Circa:* 1891

*Pattern:* Cromwell I
*Circa:* 1892

*Pattern:* Ormonde
*Circa:* 1894

*Pattern:* Columbus
*Circa:* 1895

*Pattern:* Raleigh
*Circa:* 1903

*Pattern:* Eastlake
*Circa:* 1886

*Pattern:* Chevalier
*Circa:* 1895

*Pattern:* Cromwell II
*Circa:* 1895

*Pattern:* Princess
*Circa:* 1897

*Pattern:* Lilian
*Circa:* 1882

*Pattern:* Lexington
*Circa:* 1904

*Pattern:* Mayflower
*Circa:* 1903

# ⚓ *Rogers* ⚓

*Pattern:* **General Putman**
*Circa:* **1917**

*Pattern:* La Touraine
*Circa:* 1927

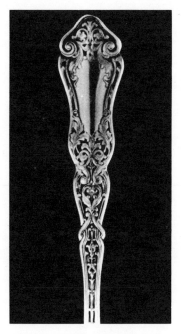

*Pattern:* Alhambra
*Circa:* 1907

*Pattern:* Beauty
*Circa:* 1909

*Pattern:* Lyonnaise
*Circa:* 1879

*Pattern:* Cottage
*Circa:* 1879

*Pattern:* Parisian
*Circa:* 1879

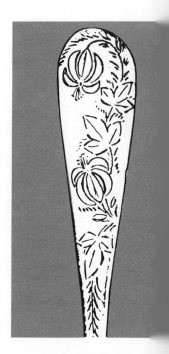

*Pattern:* Tiger Lily
*Circa:* 1895

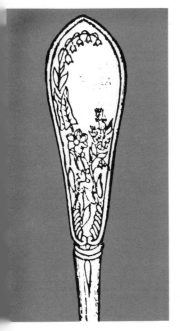

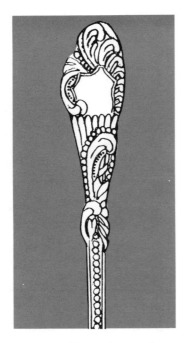

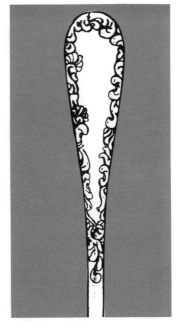

*Pattern:* Lily
*Circa:* 1879

*Pattern:* Pequot
*Circa:* 1892

*Pattern:* Victoria
*Circa:* 1895

*Pattern:* America
*Circa:* 1903

*Pattern:* Puritan
*Circa:* 1912

*Pattern:* Argyle
*Circa:* 1913

*Pattern:* Oval Thread
*Circa:* 1874

*Pattern:* Olive
*Circa:* 1879

# ⚓ *Rogers* ⚓

*Pattern:* Dunraven
*Circa:* 1895

*Pattern:* Cardinal
*Circa:* 1896

*Pattern:* Saxon
*Circa:* 1874

*Pattern:* Imperial
*Circa:* 1879

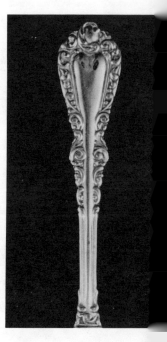

*Pattern:* Gracious
*Circa:* 1940

*Pattern:* Precious
*Circa:* 1941

*Pattern:* Laurel
*Circa:* 1878

*Pattern:* Plymouth
*Circa:* 1897

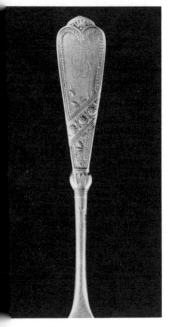

*Pattern:* Newport
*Circa:* 1880

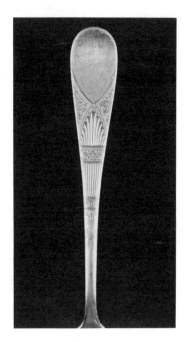

*Pattern:* Peerless
*Circa:* 1891

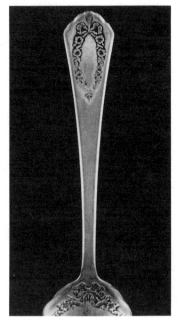

*Pattern:* Virginia
*Circa:* 1916

*Pattern:* Burlington
*Circa:* 1917

*Pattern:* Vendome
*Circa:* 1924

*Pattern:* Moonlight
*Circa:* 1959

*Pattern:* Elegance
*Circa:* 1954

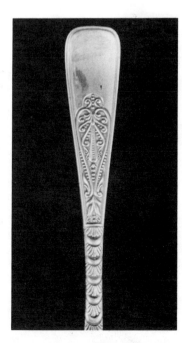

*Pattern:* Assyrian
*Circa:* 1889

# ⚓ *Rogers* ⚓

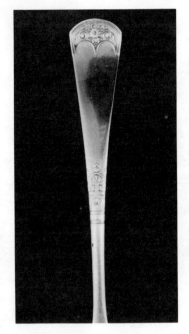

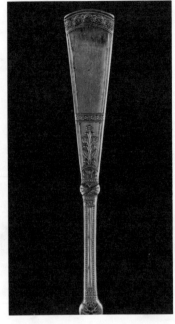

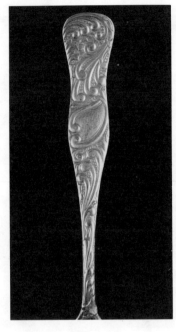

*Pattern:* Alaska
*Circa:* 1890

*Pattern:* Saratoga
*Circa:* 1886

*Pattern:* Triumph
*Circa:* 1890

# C. Rogers & Bros.

*Pattern:* Winthrop
*Circa:* 1884

*Pattern:* Royal
*Circa:* 1890

*Pattern:* Lenox
*Circa:* 1890

*Pattern:* Beaded
*Circa:* 1902

# C. Rogers & Bros.

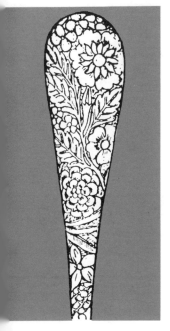

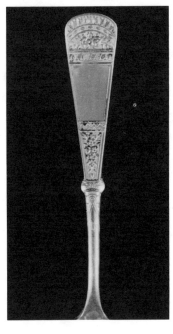

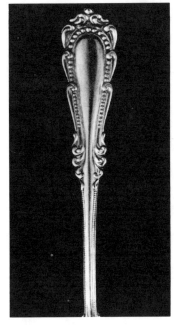

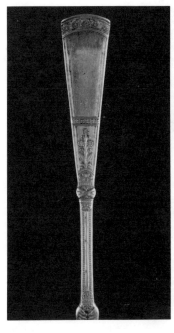

*Pattern:* Mayflower
*Circa:* 1902

*Pattern:* Westminster
*Circa:* 1896

*Pattern:* Chelsea
*Circa:* 1905

*Pattern:* Saratoga
*Circa:* 1896

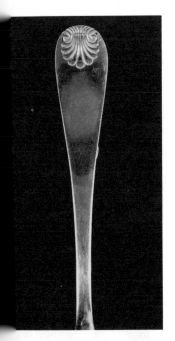

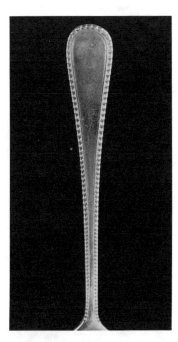

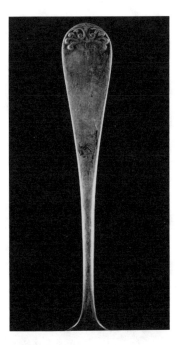

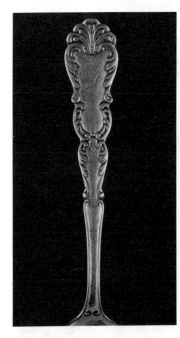

*Pattern:* Shell
*Circa:* 1896

*Pattern:* Pluto
*Circa:* 1897

*Pattern:* Spray
*Circa:* 1891

*Pattern:* Regent
*Circa:* 1894

# C. Rogers & Bros.

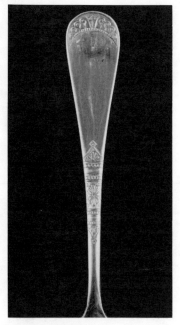

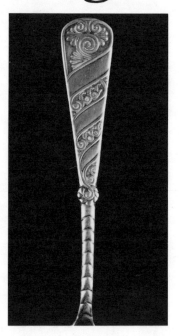

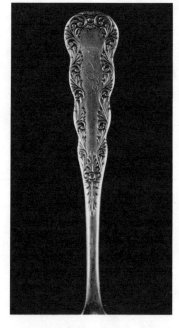

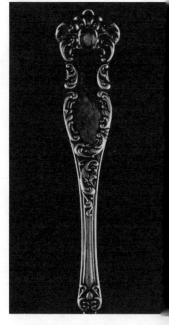

*Pattern:* Ruby
*Circa:* 1880

*Pattern:* Belmont
*Circa:* 1890

*Pattern:* Imperial
*Circa:* 1893

*Pattern:* Oxford
*Circa:* 1901

# Wm. Rogers ★

*Pattern:* Countess
*Circa:* 1880

*Pattern:* St. James
*Circa:* 1881

*Pattern:* Silver
*Circa:* 1884

*Pattern:* Seville
*Circa:* 1896

# ✸ Wm. Rogers ★

*Pattern:* Athens
*Circa:* 1884

*Pattern:* Blenheim
*Circa:* 1886

*Pattern:* Cardinal
*Circa:* 1891

*Pattern:* Melrose
*Circa:* 1898

*Pattern:* Pansy
*Circa:* 1891

*Pattern:* Blue Point
*Circa:* 1891

*Pattern:* Cedric
*Circa:* 1906

*Pattern:* York
*Circa:* 1900

# ✹ *Wm. Rogers* ★

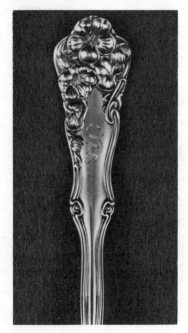

*Pattern:* Diana
*Circa:* 1904

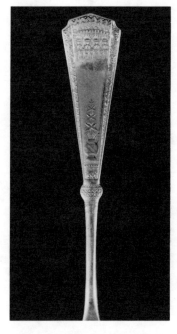

*Pattern:* San Diego
*Circa:* 1889

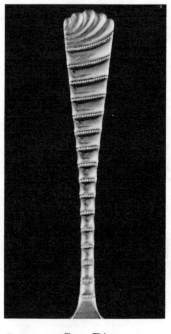

*Pattern:* Geneva
*Circa:* 1890

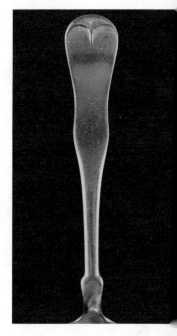

*Pattern:* Fiddle
*Circa:* 1884

*Pattern:* French
*Circa:* 1884

*Pattern:* Micado
*Circa:* 1891

*Pattern:* St. Augustine
*Circa:* 1891

*Pattern:* Queen
*Circa:* 1891

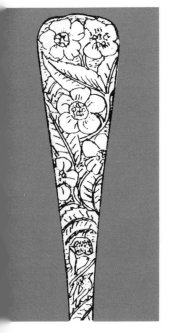

*Pattern:* Magnolia
*Circa:* 1891

*Pattern:* Yale II
*Circa:* 1891

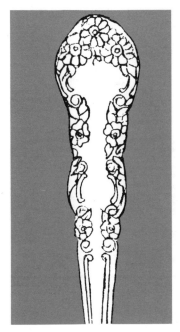

*Pattern:* Hardwick
*Circa:* 1908

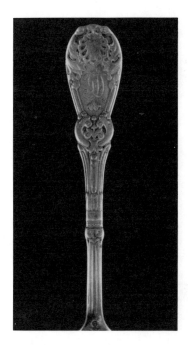

*Pattern:* Tuxedo
*Circa:* 1890

*Pattern:* Yale
*Circa:* 1894

*Pattern:* Raja
*Circa:* 1891

*Pattern:* Shell
*Circa:* 1895

*Pattern:* Beaded
*Circa:* 1904

# ☙Wm. Rogers ★

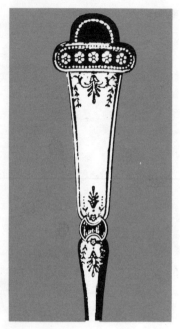

Pattern: Venetian
Circa: 1884

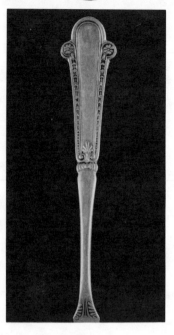

Pattern: Linden
Circa: 1878

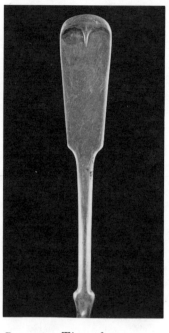

Pattern: Tipped
Circa: 1880

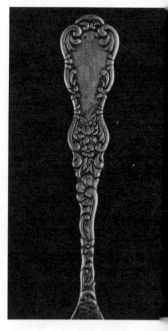

Pattern: Harvard
Circa: 1891

Pattern: Anchor
Circa: 1891

Pattern: Berwick
Circa: 1904

Pattern: Champlain
Circa: 1912

Pattern: Egyptian
Circa: 1879

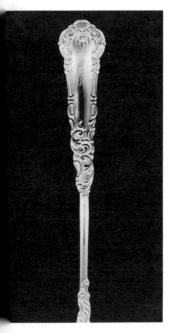

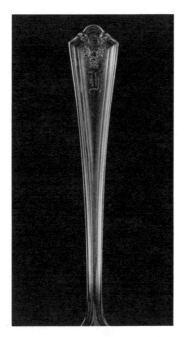

*Pattern:* Cordova
*Circa:* 1898

*Pattern:* Randolph
*Circa:* 1905

*Pattern:* Ashland
*Circa:* 1914

*Pattern:* Concord
*Circa:* 1910

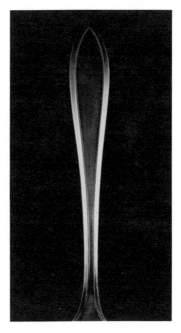

*Pattern:* Lufberry
*Circa:* 1915

*Pattern:* Pickwick
*Circa:* 1938

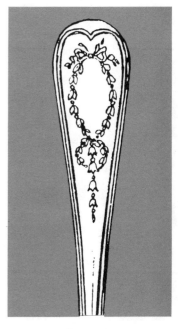

*Pattern:* Garrick
*Circa:* 1908

*Pattern:* King
*Circa:* 1891

# ❦Wm. Rogers ★

*Pattern:* Elite
*Circa:* 1934

*Pattern:* Claridge
*Circa:* 1932

*Pattern:* Spring Charm
*Circa:* 1950

*Pattern:* Rosemary
*Circa:* 1919

*Pattern:* Louisiane
*Circa:* 1938

*Pattern:* Treasure
*Circa:* 1940

*Pattern:* Homestead
*Circa:* 1922

*Pattern:* Puritan
*Circa:* 1908

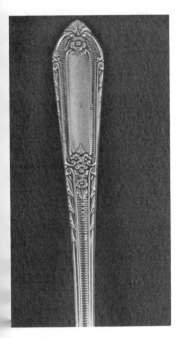

*Pattern:* Colillion
*Circa:* 1937

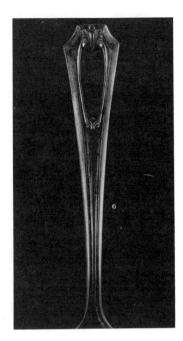

*Pattern:* Fairmount
*Circa:* 1931

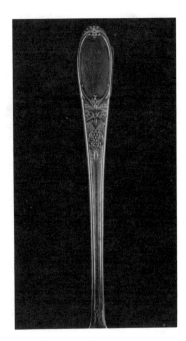

*Pattern:* Burgundy
*Circa:* 1934

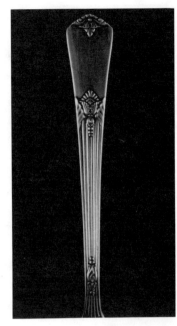

*Pattern:* Guild
*Circa:* 1935

*Pattern:* Memory
*Circa:* 1937

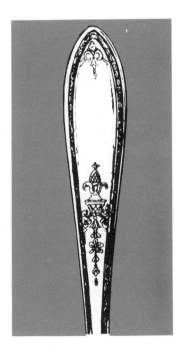

*Pattern:* Victory
*Circa:* 1938

*Pattern:* **Regent**
*Circa:* **1939**

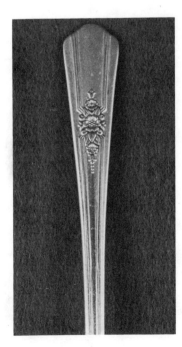

*Pattern:* Desire
*Circa:* 1941

# ✴*Wm. Rogers* ★

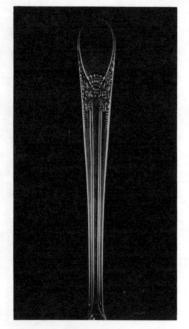

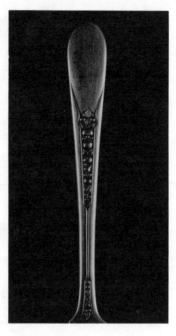

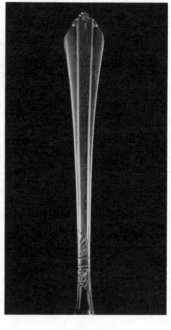

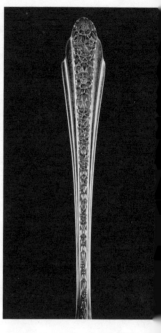

*Pattern:* Beloved
*Circa:* 1940

*Pattern:* Pricilla
*Circa:* 1941

*Pattern:* Hostess
*Circa:* 1942

*Pattern:* Modern Rose
*Circa:* 1945

*Pattern:* Imperial
*Circa:* 1939

*Pattern:* Basque Rose
*Circa:* 1951

*Pattern:* Precious Mirror
*Circa:* 1954

*Pattern:* Lady Fair
*Circa:* 1957

# ✹ Wm. Rogers ★

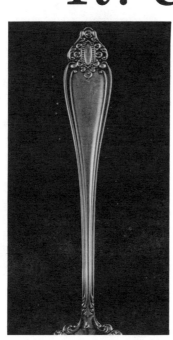

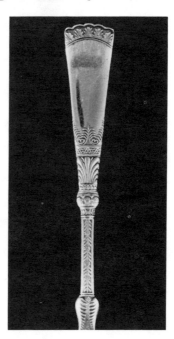

*Pattern:* Starlight
*Circa:* 1953

*Pattern:* Sweep
*Circa:* 1958

# R. & B.

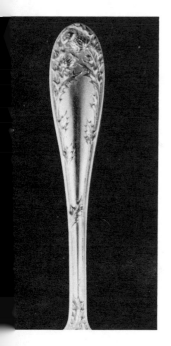

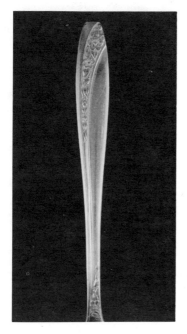

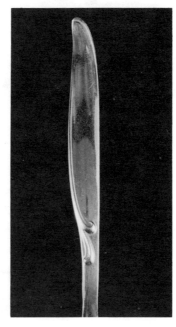

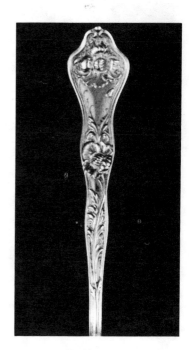

*Pattern:* Thistle
*Circa:* 1900

*Pattern:* Marquise
*Circa:* 1900

*Pattern:* Attica
*Circa:* 1895

*Pattern:* Poppy
*Circa:* 1914

# R. & B.

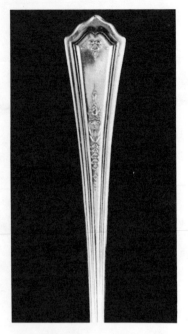

*Pattern:* Manor*
*Circa:* 1923

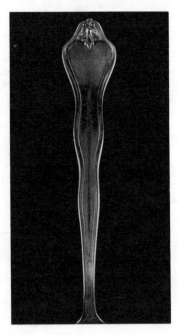

*Pattern:* Elton
*Circa:* 1919

*Pattern:* Arlington
*Circa:* 1938

*Pattern:* Ideal
*Circa:* 1923

*Pattern:* Lyric
*Circa:* 1926

*Pattern:* Roberta
*Circa:* 1938

*Pattern:* Princess
*Circa:* 1921

*Pattern:* Jewell
*Circa:* 1923

# Rogers & Bros.

*Pattern:* Diamond
*Circa:* 1886

*Pattern:* Rajah
*Circa:* 1893

*Pattern:* Oval
*Circa:* 1865

*Pattern:* Persian
*Circa:* 1871

*Pattern:* Shell
*Circa:* 1895

*Pattern:* Elton
*Circa:* 1900

# Rogers & Bros.

*Pattern:* French
*Circa:* 1874

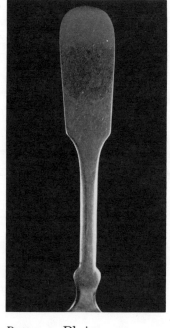

*Pattern:* Tipped
*Circa:* 1872

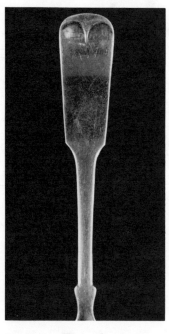

*Pattern:* Plain
*Circa:* 1865

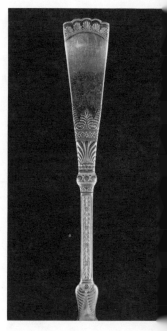

*Pattern:* Attica
*Circa:* 1895

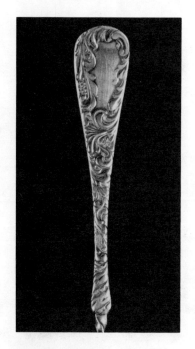

*Pattern:* Crystal
*Circa:* 1895

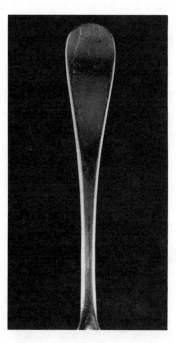

*Pattern:* Windsor
*Circa:* 1886

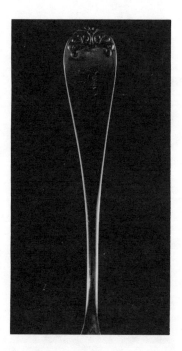

*Pattern:* Spray
*Circa:* 1887

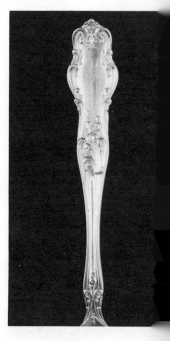

*Pattern:* Tudor
*Circa:* 1905

*Pattern:* Doric
*Circa:* 1910

*Pattern:* Roman
*Circa:* 1880

*Pattern:* Silver
*Circa:* 1891

*Pattern:* Lorne
*Circa:* 1878

*Pattern:* Threaded
*Circa:* 1880

*Pattern:* Monarch
*Circa:* 1891

*Pattern:* Siren
*Circa:* 1891

*Pattern:* Tuscan*
*Circa:* 1852

131

# Rogers & Bros.

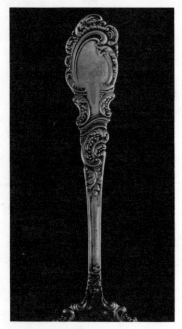

*Pattern:* Aldine
*Circa:* 1895

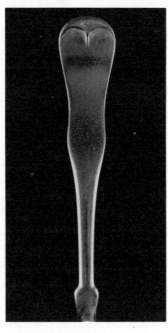

*Pattern:* Fiddle
*Circa:* 1872

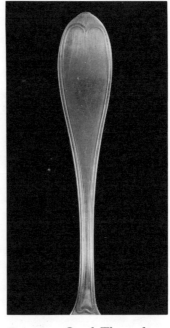

*Pattern:* Oval Thread
*Circa:* 1874

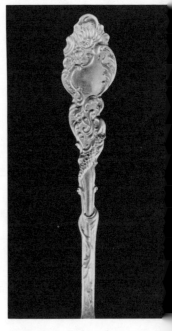

*Pattern:* Columbia
*Circa:* 1898

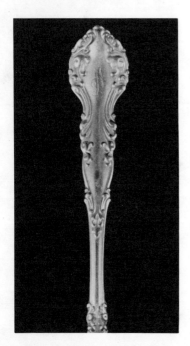

*Pattern:* New Century
*Circa:* 1898

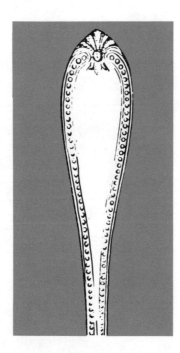

*Pattern:* Beaded
*Circa:* 1874

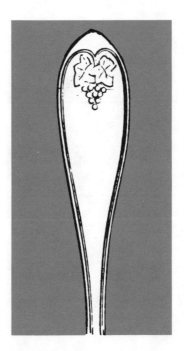

*Pattern:* Ivy
*Circa:* 1874

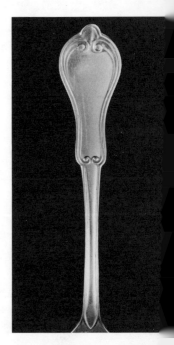

*Pattern:* Gothic
*Circa:* 1885

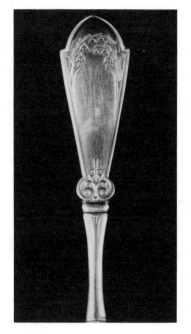
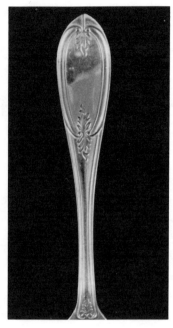

*Pattern:* Princess          *Pattern:* Olive
*Circa:* 1872               *Circa:* 1884

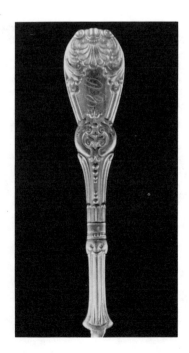
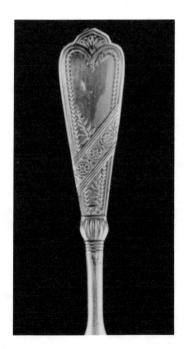

*Pattern:* Tuxedo      *Pattern:* Newport      *Pattern:* Saratoga
*Circa:* 1895         *Circa:* 1879          *Circa:* 1881

# Rogers Bros.

Pattern: Olive
Circa: 1848

Pattern: Tuscan
Circa: 1852

Pattern: Windsor
Circa: 1850

Pattern: Tipped
Circa: 1847

Pattern: Plain
Circa: 1847

Pattern: Fiddle
Circa: 1850

Pattern: Silver
Circa: 1850

# Rogers Bros. Mfg. Co.

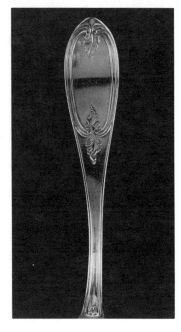

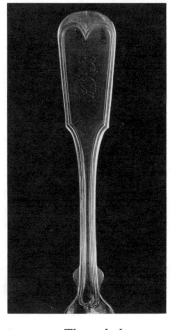

*Pattern:* Plain
*Circa:* 1853

*Pattern:* Olive
*Circa:* 1853

*Pattern:* Threaded
*Circa:* 1853

*Pattern:* Gothic
*Circa:* 1860

*Pattern:* Tipped
*Circa:* 1853

*Pattern:* Shell
*Circa:* 1860

*Pattern:* Oval
*Circa:* 1855

*Pattern:* Tuscan
*Circa:* 1853

# Rogers Bros. Mfg. Co.

*Pattern:* Fiddle
*Circa:* 1853

*Pattern:* Windsor
*Circa:* 1853

# R. C. Co.

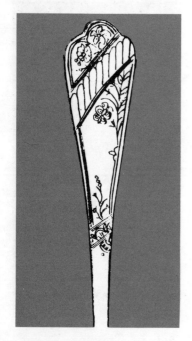

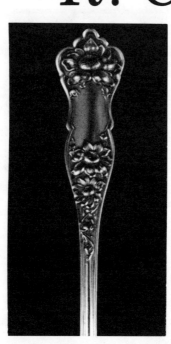

*Pattern:* Berlin
*Circa:* 1891

*Pattern:* Corona
*Circa:* 1911

*Pattern:* Isabella
*Circa:* 1913

*Pattern:* Manchester
*Circa:* 1923

# R. C. Co.

  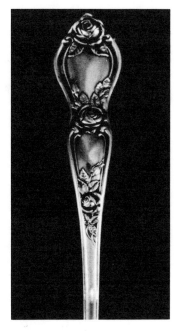 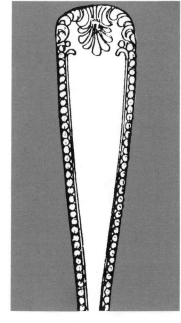

*Pattern:* Vendome
*Circa:* 1924

*Pattern:* Tipped
*Circa:* 1904

*Pattern:* Rose
*Circa:* 1910

*Pattern:* Orleans I
*Circa:* 1901

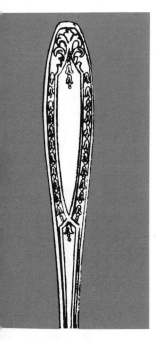 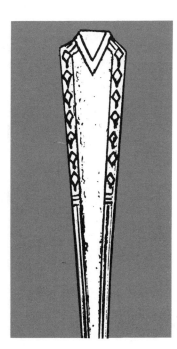  

*Pattern:* Merrill
*Circa:* 1930

*Pattern:* Admiral
*Circa:* 1940

*Pattern:* Orleans II
*Circa:* 1927

*Pattern:* Chatham
*Circa:* 1927

# Rogers & Hamilton

*Pattern:* Aldine
*Circa:* 1896

*Pattern:* Tudor
*Circa:* 1909

*Pattern:* Tipped
*Circa:* 1900

*Pattern:* Ideal
*Circa:* 1909

*Pattern:* Cardinal
*Circa:* 1887

*Pattern:* Monarch
*Circa:* 1889

*Pattern:* Newport
*Circa:* 1890

*Pattern:* Imperial
*Circa:* 1902

*Pattern:* Doric
*Circa:* 1909

*Pattern:* Marquis
*Circa:* 1900

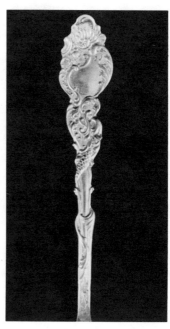

*Pattern:* Raphael
*Circa:* 1896

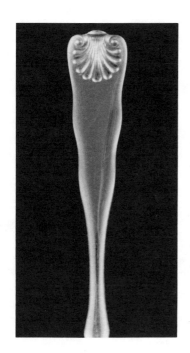

*Pattern:* Shell
*Circa:* 1897

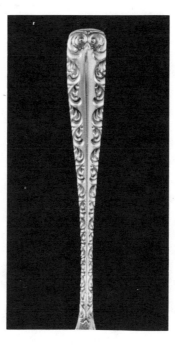

*Pattern:* Majestic
*Circa:* 1897

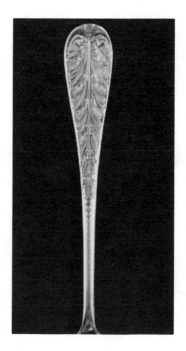

*Pattern:* Acanthus
*Circa:* 1886

# ★ ♥ *Rogers Smith & Co.*

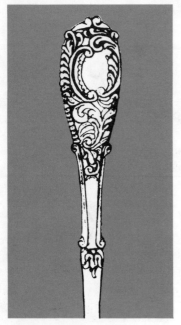

*Pattern:* Moline
*Circa:* 1893

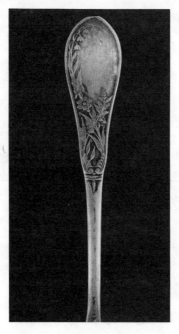

*Pattern:* Lily
*Circa:* Prior to 1878

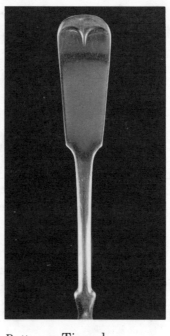

*Pattern:* Tipped
*Circa:* 1886

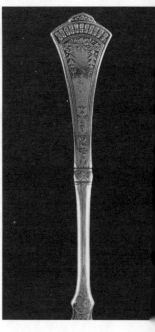

*Pattern:* Crown
*Circa:* 1886

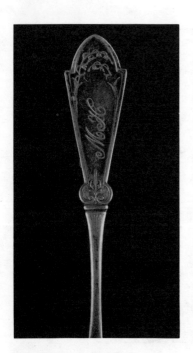

*Pattern:* Princess
*Circa:* 1886

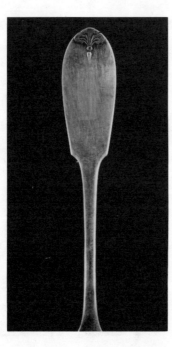

*Pattern:* Shell Tipped
*Circa:* 1886

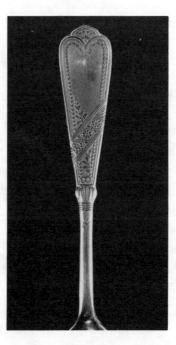

*Pattern:* Newport
*Circa:* 1880

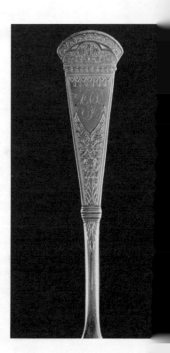

*Pattern:* Imperial
*Circa:* 1886

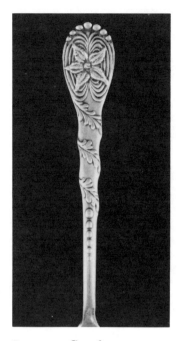

*Pattern:* Plain
*Circa:* 1860

*Pattern:* Fiddle
*Circa:* 1870

*Pattern:* Coral
*Circa:* 1885

*Pattern:* Venetian
*Circa:* 1886

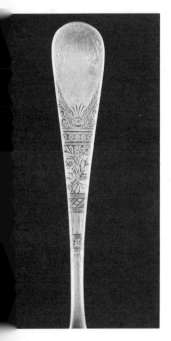

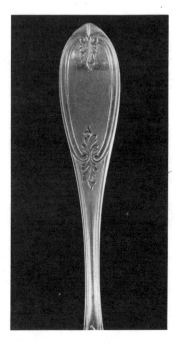

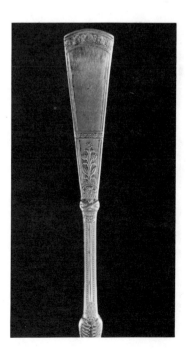

*Pattern:* Lorne
*Circa:* 1878

*Pattern:* Windsor
*Circa:* 1878

*Pattern:* Olive
*Circa:* 1856

*Pattern:* Saratoga
*Circa:* 1878

# Simeon L. & George H. Rogers Co.

*Pattern:* Windsor
*Circa:* 1900

*Pattern:* Tipped
*Circa:* 1900

*Pattern:* Lakewood
*Circa:* 1901

*Pattern:* Webster
*Circa:* 1901

*Pattern:* Fiddle
*Circa:* 1900

*Pattern:* Violet
*Circa:* 1905

*Pattern:* Colonial
*Circa:* 1909

*Pattern:* Daisy
*Circa:* 1910

*Pattern:* Princess
*Circa:* 1901

*Pattern:* Shell
*Circa:* 1901

*Pattern:* Minerva
*Circa:* 1910

*Pattern:* Jefferson
*Circa:* 1913

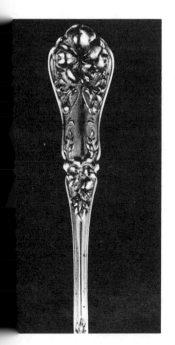

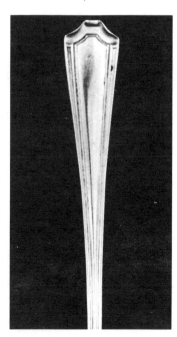

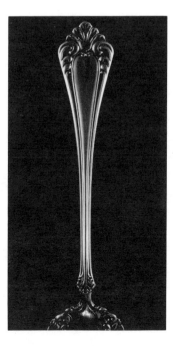

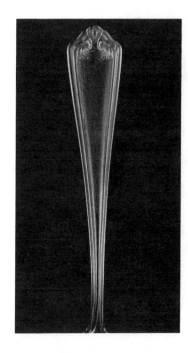

*Pattern:* Pansy
*Circa:* 1914

*Pattern:* Lexington
*Circa:* 1914

*Pattern:* Puritan
*Circa:* 1904

*Pattern:* Laureate
*Circa:* 1914

# Simeon L. & George H. Rogers Co.

*Pattern:* Andover
*Circa:* 1939

*Pattern:* Jasmine
*Circa:* 1941

*Pattern:* Faun
*Circa:* 1930

*Pattern:* Countess I
*Circa:* 1930

*Pattern:* Gloria
*Circa:* 1930

*Pattern:* Silver Rose
*Circa:* 1951

*Pattern:* Countess II
*Circa:* 1939

*Pattern:* Fenway
*Circa:* 1938

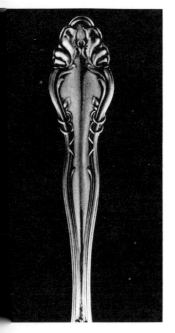

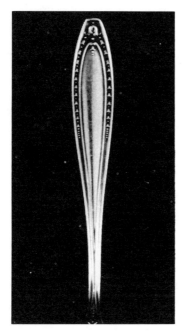

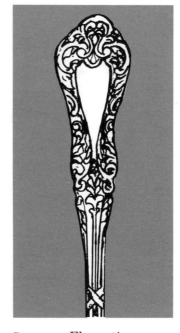

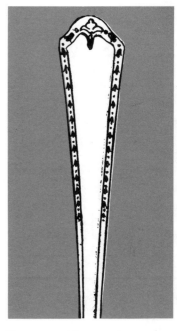

*Pattern:* Arcadia
*Circa:* 1914

*Pattern:* Webster
*Circa:* 1915

*Pattern:* Florentine
*Circa:* 1910

*Pattern:* Algonquin
*Circa:* 1923

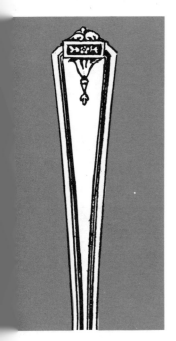

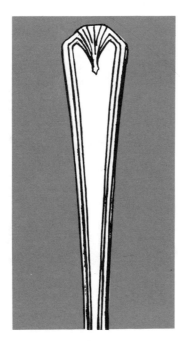

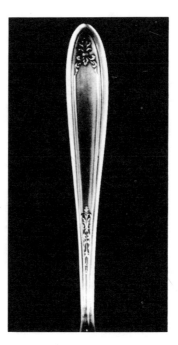

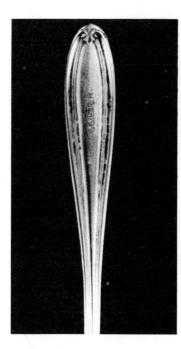

*Pattern:* Crest
*Circa:* 1930

*Pattern:* Viking
*Circa:* 1931

*Pattern:* Roxbury
*Circa:* 1923

*Pattern:* Commodore
*Circa:* 1929

# Simeon L. & George H. Rogers Co.

*Pattern:* Orchid
*Circa:* 1903

*Pattern:* Encore
*Circa:* 1929

*Pattern:* Oxford
*Circa:* 1938

*Pattern:* Sunrise
*Circa:* 1939

*Pattern:* Courtney
*Circa:* 1935

*Pattern:* Thor
*Circa:* 1939

*Pattern:* Kingston
*Circa:* 1938

*Pattern:* English Gard
*Circa:* 1951

# ★ Rogers & Bros.

Pattern: Fiddle
Circa: 1874

Pattern: Tipped
Circa: Prior to 1878

Pattern: Oval Threaded
Circa: 1884

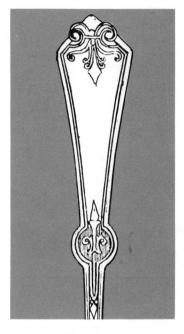

Pattern: Persian
Circa: 1874

Pattern: Crown
Circa: 1885

Pattern: Savoy
Circa: 1897

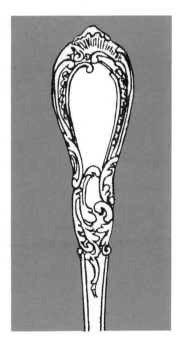

Pattern: Navarre
Circa: 1898

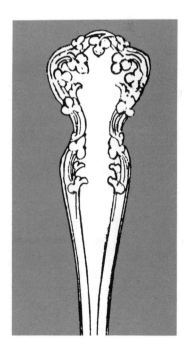

Pattern: Belmont
Circa: 1907

# ★ Rogers & Bros.

*Pattern:* Mystic
*Circa:* 1903

*Pattern:* Flanders
*Circa:* 1905

*Pattern:* Crest
*Circa:* 1906

*Pattern:* Grape
*Circa:* 1872

*Pattern:* Florette
*Circa:* 1909

*Pattern:* Admeral
*Circa:* 1918

*Pattern:* Flemish
*Circa:* 1893

*Pattern:* Empire
*Circa:* 1921

*Pattern:* St. Moritz
*Circa:* 1910

*Pattern:* Verona
*Circa:* 1910

*Pattern:* York
*Circa:* 1900

*Pattern:* Grecian
*Circa:* 1923

*Pattern:* Inspiration
*Circa:* 1933

*Pattern:* Majestic
*Circa:* 1932

*Pattern:* Aurora
*Circa:* 1933

*Pattern:* Georgic
*Circa:* 1938

# ★ *Rogers & Bros.*

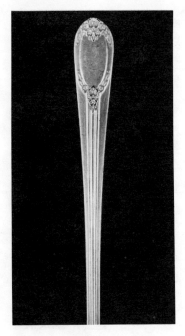

*Pattern:* Rapture
*Circa:* 1952

*Pattern:* Exquisite
*Circa:* 1957

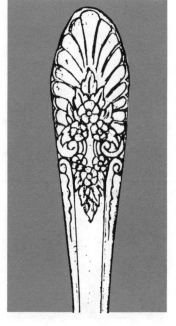

*Pattern:* Riviera Revisited
*Circa:* 1954

*Pattern:* Oval Threaded
*Circa:* 1884

# ✠ *W. R.* ⬓

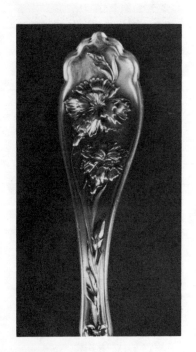

*Pattern:* Carnation
*Circa:* 1908

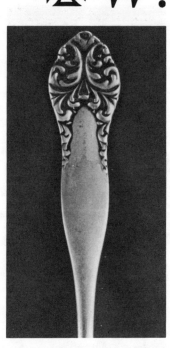

*Pattern:* Leonora
*Circa:* 1914

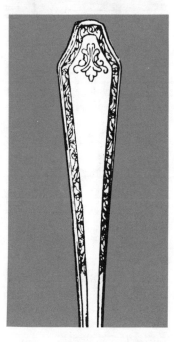

*Pattern:* Alden
*Circa:* 1931

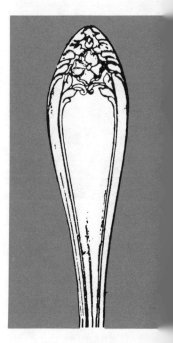

*Pattern:* Greylock
*Circa:* 1910

# ✠ *W. R.* ⬙

*Pattern:* Wellesley
*Circa:* 1916

*Pattern:* Shell
*Circa:* 1912

*Pattern:* Sherwood
*Circa:* 1913

*Pattern:* Amherst
*Circa:* 1938

*Pattern:* Nuart
*Circa:* 1932

*Pattern:* Irving
*Circa:* 1916

*Pattern:* Laureate
*Circa:* 1914

*Pattern:* Belvedere
*Circa:* 1925

# Wm. A. Rogers

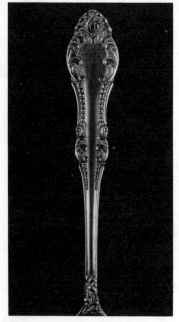

*Pattern:* Carlton
*Circa:* 1898

*Pattern:* Shell
*Circa:* 1898

*Pattern:* Windsor
*Circa:* 1891

*Pattern:* Tipped
*Circa:* 1898

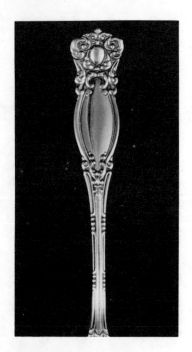

*Pattern:* Warwick
*Circa:* 1901

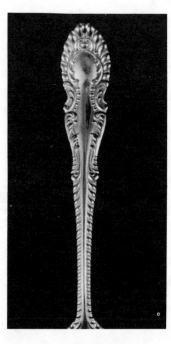

*Pattern:* Elberon
*Circa:* 1897

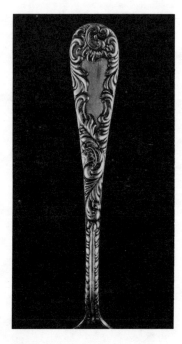

*Pattern:* Vernon
*Circa:* 1910

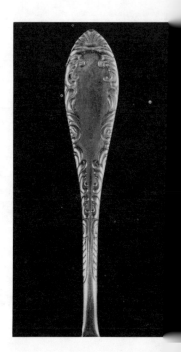

*Pattern:* Rhinebeck
*Circa:* 1900

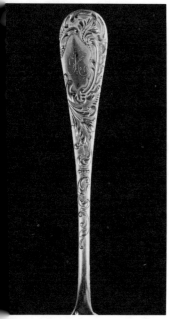

*Pattern:* Elmore
*Circa:* 1905

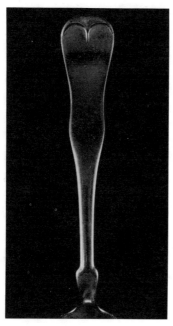

*Pattern:* Fiddle
*Circa:* 1900

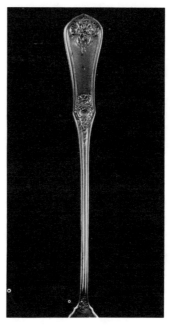

*Pattern:* Garland
*Circa:* 1900

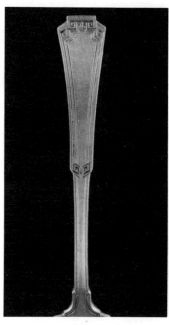

*Pattern:* Grecian
*Circa:* 1907

*Pattern:* Leyland
*Circa:* 1910

*Pattern:* Arundel
*Circa:* 1899

*Pattern:* Hanover
*Circa:* 1901

*Pattern:* Carnation
*Circa:* 1908

# Wm. A. Rogers

*Pattern:* La Concorde
*Circa:* 1910

*Pattern:* Eudora
*Circa:* 1905

*Pattern:* Marcella
*Circa:* 1905

*Pattern:* Sherwood
*Circa:* 1913

*Pattern:* Alden
*Circa:* 1931

*Pattern:* Grenoble
*Circa:* 1906

*Pattern:* Concord
*Circa:* 1910

*Pattern:* Suffolk
*Circa:* 1913

*Pattern:* Abington
*Circa:* 1910

*Pattern:* Leonora
*Circa:* 1914

*Pattern:* Debutante
*Circa:* 1931

*Pattern:* Mary Lee
*Circa:* 1932

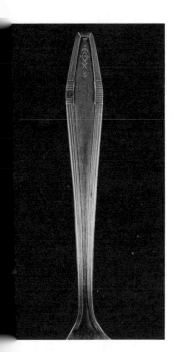

*Pattern:* Countess
*Circa:* 1930

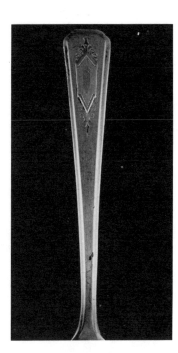

*Pattern:* Nuart
*Circa:* 1932

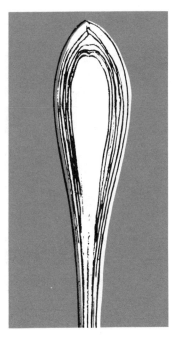

*Pattern:* Standish
*Circa:* 1914

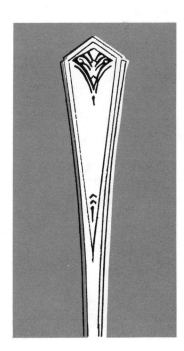

*Pattern:* Flight
*Circa:* 1931

# Wm. A. Rogers

*Pattern:* Columbia
*Circa:* 1913

*Pattern:* Amherst
*Circa:* 1938

*Pattern:* Rendevous
*Circa:* 1939

*Pattern:* Brittany Rose
*Circa:* 1948

*Pattern:* Croydon
*Circa:* 1936

*Pattern:* Meadowbrook
*Circa:* 1940

*Pattern:* Valley Rose
*Circa:* 1957

# Wm. A. Rogers

Pattern:  Margate
Circa:  1939

Pattern:  Everlasting
Circa:  1949

# W. F. Rogers

ttern:  Tipped
Circa:  1902

Pattern:  Shell
Circa:  1902

Pattern:  Winthrop
Circa:  1884

Pattern:  Imperial
Circa:  1893

# Wm. Rogers Mfg. Co.

*Pattern:* Pequot
*Circa:* 1892

*Pattern:* Fiddle
*Circa:* 1882

*Pattern:* Ormonde
*Circa:* 1895

*Pattern:* Plain
*Circa:* 1882

*Pattern:* Persian
*Circa:* 1882

*Pattern:* Blenheim
*Circa:* 1886

*Pattern:* Florida
*Circa:* 1894

*Pattern:* Berwick
*Circa:* 1906

*Pattern:* **Arbutus**
*Circa:* 1908

*Pattern:* **Essex**
*Circa:* 1910

*Pattern:* **Princess**
*Circa:* 1872

*Pattern:* **St. James**
*Circa:* 1880

*Pattern:* **Saratoga**
*Circa:* 1889

*Pattern:* **Oxford**
*Circa:* 1904

*Pattern:* **Geneva**
*Circa:* 1900

*Pattern:* **York**
*Circa:* 1900

# Wm. Rogers Mfg. Co.

*Pattern:* Chevalier
*Circa:* 1897

*Pattern:* Chelsea
*Circa:* 1904

*Pattern:* Tipped
*Circa:* 1882

*Pattern:* Windsor
*Circa:* 1891

*Pattern:* Victoria
*Circa:* 1895

*Pattern:* Daisey
*Circa:* 1910

*Pattern:* Peerless
*Circa:* 1891

*Pattern:* Shell
*Circa:* 1895

*tern:* Harvard
*irca:* 1897

*Pattern:* Orchid
*Circa:* 1911

*Pattern:* Danish
*Circa:* 1882

*Pattern:* Berlin
*Circa:* 1882

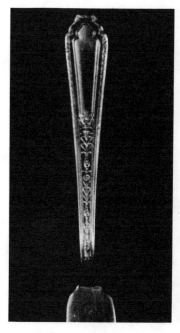

*rn:* Olive
*ca:* 1865

*Pattern:* Alhambra
*Circa:* 1907

*Pattern:* Columbia
*Circa:* 1895

*Pattern:* Chalfonte
*Circa:* 1926

# Wm. Rogers Mfg. Co.

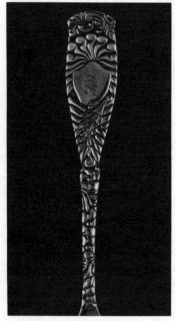

*Pattern:* Scroll
*Circa:* 1890

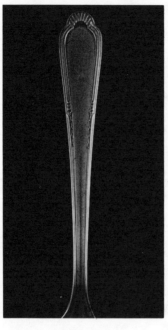

*Pattern:* Laurel
*Circa:* 1934

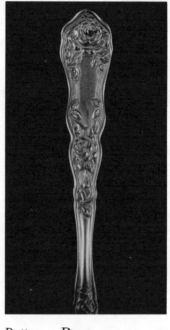

*Pattern:* Rose
*Circa:* 1909

*Pattern:* Tapestry
*Circa:* 1940

*Pattern:* New Daisey
*Circa:* 1908

*Pattern:* Avalon
*Circa:* 1940

*Pattern:* Raleigh
*Circa:* 1904

*Pattern:* Mount Royal
*Circa:* 1924

*Pattern:* Flower    *Pattern:* Claridge    *Pattern:* America    *Pattern:* Regent
*Circa:* 1908    *Circa:* 1919    *Circa:* 1903    *Circa:* 1927

*attern:* Fidelis    *Pattern:* Louisiane    *Pattern:* Inheritance    *Pattern:* California Blossom
*Circa:* 1933    *Circa:* 1938    *Circa:* 1941    *Circa:* 1941

# Wm. Rogers Mfg. Co.

*Pattern:* Lyric
*Circa:* 1939

*Pattern:* Allure
*Circa:* 1939

*Pattern:* Legion
*Circa:* 1931

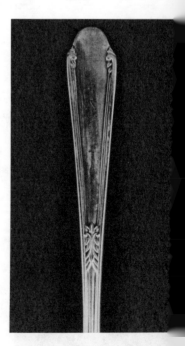

*Pattern:* Pickwick
*Circa:* 1938

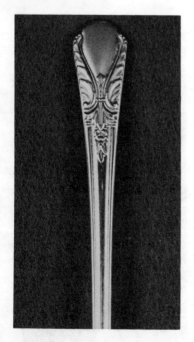

*Pattern:* Cabin
*Circa:* 1941

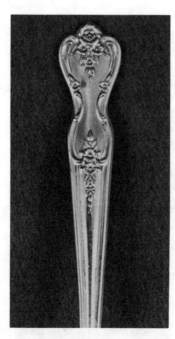

*Pattern:* Magnolia
*Circa:* 1951

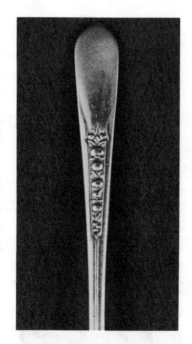

*Pattern:* Pricilla
*Circa:* 1939

*Pattern:* Admiration
*Circa:* 1940

# Wm. Rogers Mfg Co.

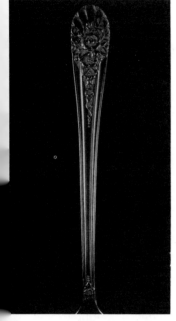

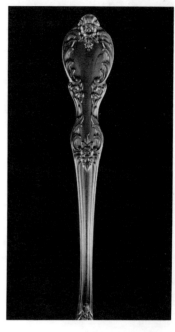

*Pattern:* Jubilee
*Circa:* 1953

*Pattern:* Tupperware Rose
*Circa:* 1955

*Pattern:* Citrus
*Circa:* 1957

*Pattern:* Grand Elegance
*Circa:* 1959

# Wm. Rogers & Son

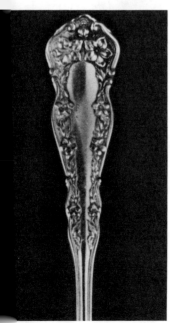

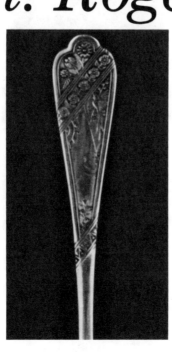

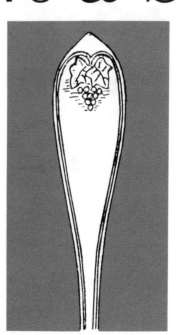

*Pattern:* Lyonnaise
*Circa:* 1890

*Pattern:* Chester
*Circa:* Early 1900s

*Pattern:* Ivy (Grape)
*Circa:* 1872

*Pattern:* Fenwick
*Circa:* 1905

# Wm. Rogers & Son

*Pattern:* Beaded
*Circa:* 1912

*Pattern:* Liberty
*Circa:* 1895

*Pattern:* Milton
*Circa:* 1897

*Pattern:* Tipped
*Circa:* 1901

*Pattern:* Primrose
*Circa:* 1912

*Pattern:* Imperial
*Circa:* 1882

*Pattern:* Romanesque
*Circa:* 1898

*Pattern:* Moline
*Circa:* 1893

*Pattern:* Shell
*Circa:* 1890

*Pattern:* Florida
*Circa:* 1894

*Pattern:* Argyle
*Circa:* 1913

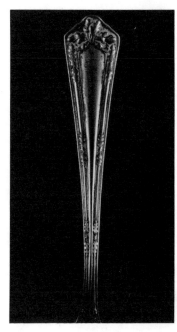

*Pattern:* Fair Oak
*Circa:* 1913

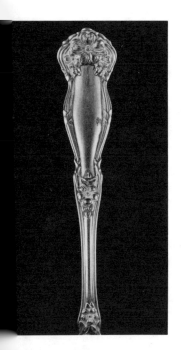

*Pattern:* Arbutus
*Circa:* 1908

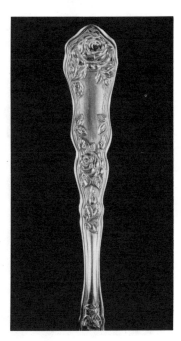

*Pattern:* Rose
*Circa:* 1909

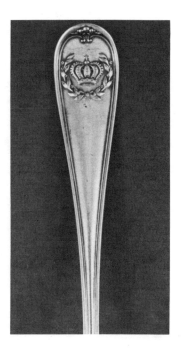

*Pattern:* Crown
*Circa:* Early 1900s

*Pattern:* Oxford
*Circa:* 1908

# Wm. Rogers & Son

*Pattern:* Scroll
*Circa:* 1890

*Pattern:* Orange Blossom
*Circa:* 1910

*Pattern:* Sunkist
*Circa:* 1910

*Pattern:* Essex
*Circa:* 1912

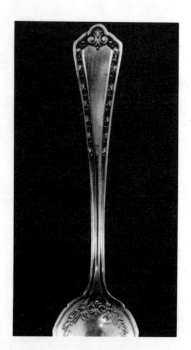

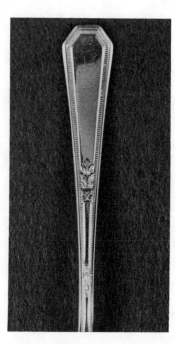

*Pattern:* Hampden
*Circa:* 1916

*Pattern:* La France
*Circa:* 1922

*Pattern:* Mayfair
*Circa:* 1923

*Pattern:* Dunster
*Circa:* 1915

*Pattern:* Clinton
*Circa:* 1916

*Pattern:* Lincoln
*Circa:* 1927

*Pattern:* Puritan
*Circa:* 1912

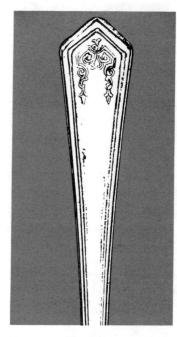

*Pattern:* La Salle
*Circa:* 1927

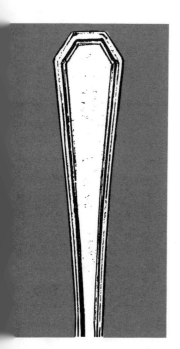

*Pattern:* DeSoto
*Circa:* 1929

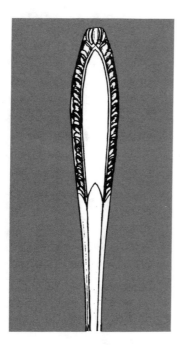

*Pattern:* Strand
*Circa:* 1935

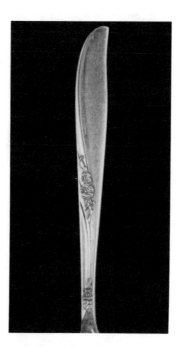

*Pattern:* Friendship
*Circa:* 1932

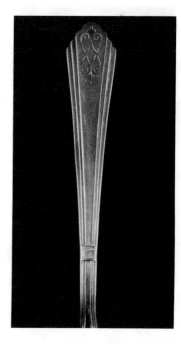

*Pattern:* Drexel
*Circa:* 1929

# Wm. Rogers & Son

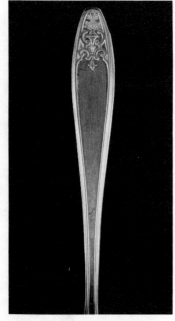

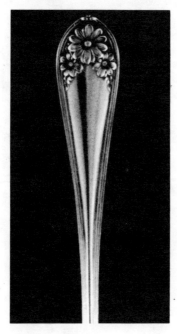

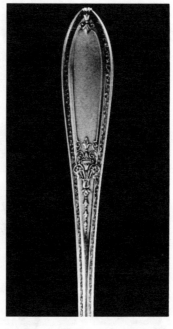

*Pattern:* Princess
*Circa:* 1929

*Pattern:* Daisey
*Circa:* 1910

*Pattern:* Triumph
*Circa:* 1925

*Pattern:* Tapestry
*Circa:* 1940

*Pattern:* Paris
*Circa:* 1933

*Pattern:* Georgic
*Circa:* 1940

*Pattern:* Primrose
*Circa:* 1952

*Pattern:* Spring Flower
*Circa:* 1956

*Pattern:* Guild
*Circa:* 1932

*Pattern:* Sea Spray
*Circa:* 1960

*Pattern:* El California
*Circa:* 1961

*Pattern:* Laurel
*Circa:* 1934

*Pattern:* Gardenia
*Circa:* 1940

*Pattern:* Exquisite
*Circa:* 1940

*Pattern:* Talisman
*Circa:* 1940

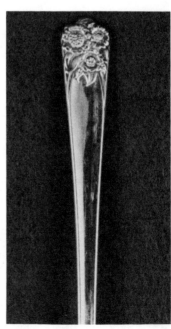

*Pattern:* April
*Circa:* 1954

171

# *Wm. Rogers & Son*

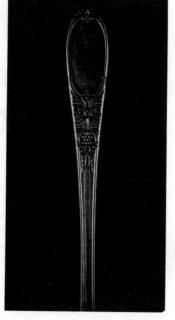

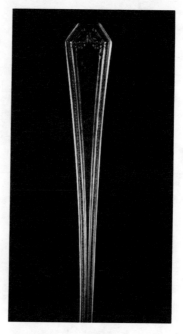

*Pattern:* Burgundy
*Circa:* 1934

*Pattern:* Lancaster
*Circa:* 1939

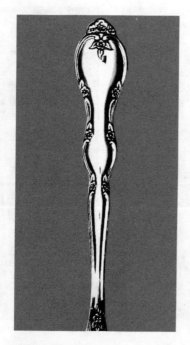

*Pattern:* Juliette
*Circa:* 1967

*Pattern:* Gaiety
*Circa:* 1967

*Pattern:* Victorian Rose
*Circa:* 1967

# 1834 J. Russell & Co.

*Pattern:* Lotus
*Circa:* 1884

# Salem Silver Plate

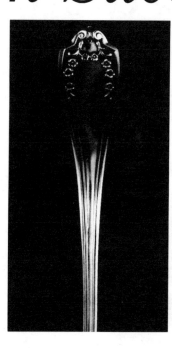

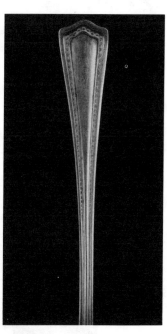

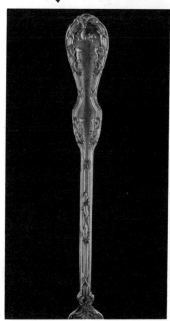

*Pattern:* Endicott
*Circa:* 1915

*Pattern:* Conant
*Circa:* 1915

*Pattern:* Broadfield
*Circa:* 1916

*Pattern:* Royal Oak
*Circa:* 1909

# Salem Silver Plate $\langle S \rangle \langle S \rangle \langle P \rangle$

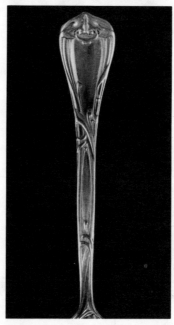

*Pattern:* Iris
*Circa:* 1914

# Simmons Hardware Co.

*Pattern:* Thistle
*Circa:* 1906

# Simpson, Hall, Miller & Co.

*Pattern:* Athens
*Circa:* 1883

*Pattern:* Olive
*Circa:* Prior to 1878

*Pattern:* Tipped
*Circa:* 1878

*Pattern:* Beaded
*Circa:* 1878

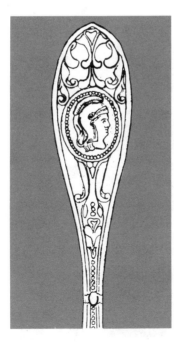

*Pattern:* Jewel
*Circa:* 1882

*Pattern:* Medallion
*Circa:* Prior to 1878

*Pattern:* Melrose
*Circa:* 1896

*Pattern:* Berwick
*Circa:* 1904

# Simpson, Hall, Miller & Co.

Pattern: Grape
Circa: 1867

Pattern: Oval Thread
Circa: Prior to 1878

# E. H. H. Smith Silver Co. ◁S▷

Pattern: Iris
Circa: 1902

Pattern: Holly
Circa: 1904

Pattern: Oak
Circa: 1906

Pattern: Rose
Circa: 1910

# E. H. H. Smith Silver Co. ◁S▷

*Pattern:* Kings
*Circa:* 1900

*Pattern:* Shell
*Circa:* 1904

*Pattern:* Verdi
*Circa:* 1904

*Pattern:* Flemish
*Circa:* 1900

*Pattern:* Antique Egyptian
*Circa:* 1909

*Pattern:* Windsor
*Circa:* 1910

# Stratford Silver Co.

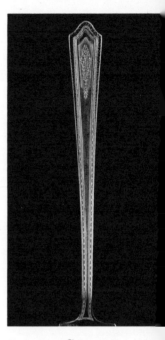

*Pattern:* Ladyship
*Circa:* 1937

*Pattern:* Starlight
*Circa:* 1939

*Pattern:* Shakespear
*Circa:* 1924

*Pattern:* Carmen
*Circa:* 1927

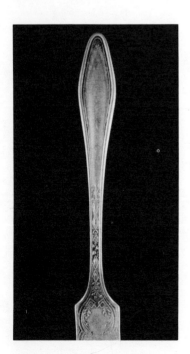

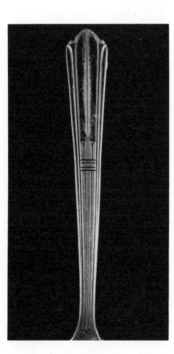

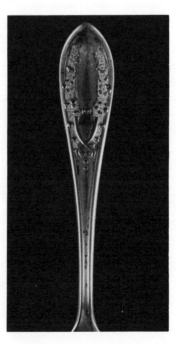

*Pattern:* Betsy Ross
*Circa:* 1923

*Pattern:* Cotillion
*Circa:* 1932

*Pattern:* Yorktown
*Circa:* 1913

*Pattern:* Virginia
*Circa:* 1917

*Pattern:* Nassau
*Circa:* 1899

*Pattern:* Tower
*Circa:* 1932

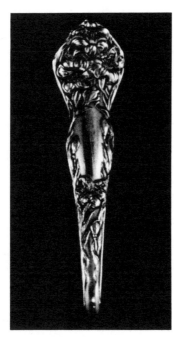

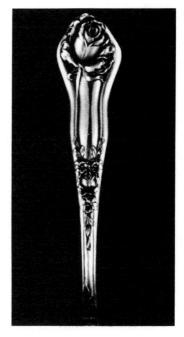

*Pattern:* Dresden
*Circa:* 1911

*Pattern:* Lilyta
*Circa:* 1911

*Pattern:* Rosedale
*Circa:* 1913

# R. Strickland

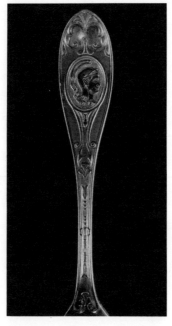 

*Pattern:* Medallion     *Pattern:* Oval Thread
*Circa:* 1865       *Circa:* Prior to 1885

# Tiffany & Co. E. P.

*Pattern:* Regent     *Pattern:* Old French
*Circa:* 1889       *Circa:* 1884

# A. F. Towle & Son Co.

*Pattern:* Arundel
*Circa:* Prior to 1902

*Pattern:* Raleigh
*Circa:* 1893

*Pattern:* Fiddle
*Circa:* 1883

*Pattern:* Windsor
*Circa:* 1883

*Pattern:* Climber
*Circa:* 1890

*Pattern:* Priscilla
*Circa:* 1897

*Pattern:* Rustic
*Circa:* Prior to 1902

*Pattern:* Tipped
*Circa:* 1883

# A. F. Towle & Son Co.

*Pattern:* Ionic
*Circa:* 1890

*Pattern:* No. 300
*Circa:* 1883

# Towle Mfg. Co.

*Pattern:* Windsor Engraved
*Circa:* 1880

*Pattern:* Eudora
*Circa:* 1888

*Pattern:* Chester
*Circa:* 1888

*Pattern:* Norwood
*Circa:* 1900

# Towle Mfg. Co.

*Pattern:* Victor
*Circa:* 1882

*Pattern:* Engraved
*Circa:* 1880

*Pattern:* Shell I
*Circa:* 1888

*Pattern:* Shell II
*Circa:* 1889

# Tradition Silverplate

*Pattern:* Bridal Corsage
*Circa:* 1956

*Pattern:* Classic Filigree
*Circa:* 1956

*Pattern:* Maytime
*Circa:* 1956

*Pattern:* Morning Glory
*Circa:* 1956

183

# Tradition Silverplate

*Pattern:* Bridal Song
*Circa:* 1956

*Pattern:* Personality
*Circa:* 1956

*Pattern:* Sonata
*Circa:* 1956

*Pattern:* Sweetheart
*Circa:* 1956

# United Silver Co.

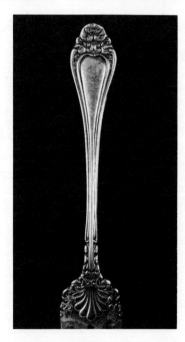

*Pattern:* Oregon
*Circa:* 1900

# Universal Silver

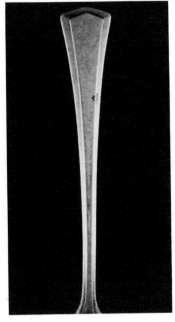

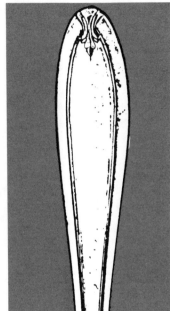

*Pattern:* Farmington
*Circa:* 1917

*Pattern:* Newington
*Circa:* 1930

*Pattern:* Saybrook
*Circa:* 1919

# Utility Silverplate

*Pattern:* Bouquet
*Circa:* 1956

*Pattern:* Magic Lily
*Circa:* 1956

# 1835 R. Wallace

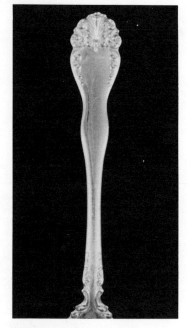

*Pattern:* Anjou
*Circa:* 1899

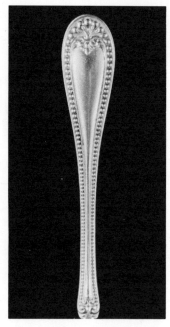

*Pattern:* Stuart
*Circa:* 1899

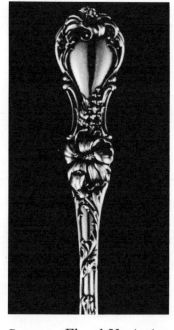

*Pattern:* Floral Variation
*Circa:* 1902

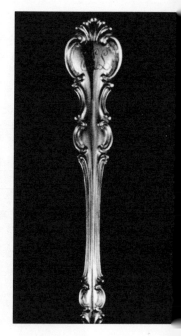

*Pattern:* Troy
*Circa:* 1902

*Pattern:* Cardinal
*Circa:* 1907

*Pattern:* Laurel
*Circa:* 1910

*Pattern:* Kings
*Circa:* 1903

*Pattern:* Abbey
*Circa:* 1937

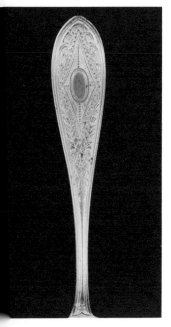

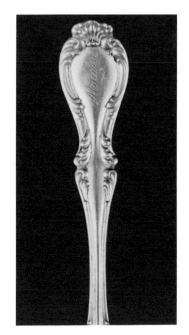

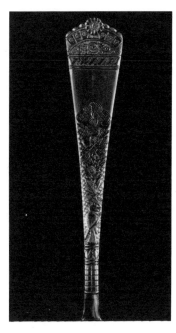

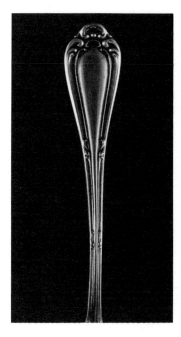

*Pattern:* Diamond
*Circa:* 1878

*Pattern:* Joan
*Circa:* 1896

*Pattern:* Alpine
*Circa:* 1881

*Pattern:* Astoria
*Circa:* 1898

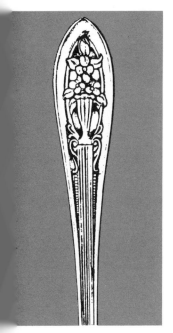

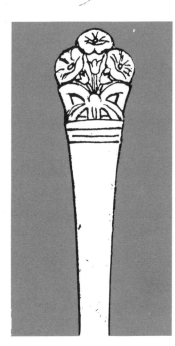

*Pattern:* Hollywood
*Circa:* 1937

*Pattern:* Morning Glory
*Circa:* 1945

*Pattern:* Flair
*Circa:* 1956

*Pattern:* Ultra
*Circa:* 1934

# 1835 R. Wallace

*Pattern:* Lady Alice
*Circa:* 1937

*Pattern:* Personality
*Circa:* 1938

*Pattern:* Southgate
*Circa:* 1937

*Pattern:* Roseanne
*Circa:* 1938

*Pattern:* Blossom
*Circa:* 1909

*Pattern:* Pearl
*Circa:* 1913

*Pattern:* Grape
*Circa:* 1927

*Pattern:* Arlington
*Circa:* 1911

*Pattern:* Hudson
*Circa:* 1917

*Pattern:* Serenade
*Circa:* 1931

*Pattern:* Athena
*Circa:* 1916

*Pattern:* Buckingham
*Circa:* 1924

*Pattern:* Shell
*Circa:* 1871

*Pattern:* Windsor
*Circa:* 1895

*Pattern:* Vogue
*Circa:* 1935

*Pattern:* Floral
*Circa:* 1902

# 1835 R. Wallace

Pattern: Trenton
Circa: 1915

Pattern: Tipped
Circa: 1888

Pattern: Vogue I
Circa: 1898

Pattern: Mode
Circa: 1930

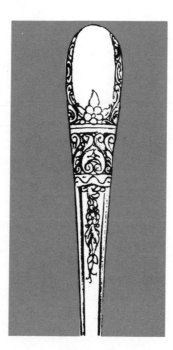

Pattern: Sweetheart
Circa: 1948

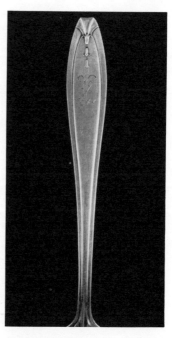

Pattern: Hostess
Circa: 1920

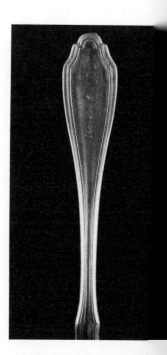

Pattern: Margaret
Circa: 1911

# 1835 R. Wallace

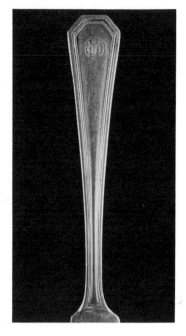

*Pattern:* Alamo
*Circa:* 1913

*Pattern:* Sonata
*Circa:* 1947

# Wallingford Co.

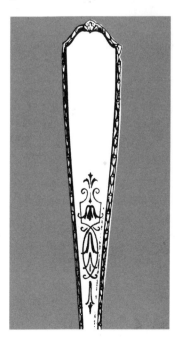

*attern:* Bedford
*Circa:* 1926

*Pattern:* Trumpet Vine
*Circa:* 1912

*Pattern:* Sharon
*Circa:* 1926

*Pattern:* Alicia
*Circa:* 1930

# Wallingford Co.

 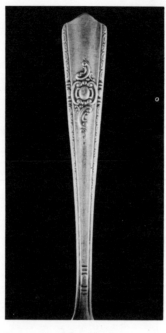 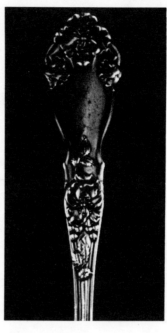 

*Pattern:* Plymouth
*Circa:* 1914

*Pattern:* Maytime
*Circa:* 1949

*Pattern:* Adams
*Circa:* 1906

*Pattern:* Marcia
*Circa:* 1920

# E. G. Webster & Bros.

*Pattern:* Cardinal
*Circa:* 1887

*Pattern:* Derby
*Circa:* 1889

# Wilcox Silver Plate Co.

*Pattern:* Regent
*Circa:* 1878

# Williams Bros. Mfg. Co.

*Pattern:* Beaded
*Circa:* 1900

*Pattern:* Vineyard
*Circa:* 1907

*Pattern:* Kensico
*Circa:* 1890

*Pattern:* Rosalind
*Circa:* 1900

# Williams Bros. Mfg. Co.

*Pattern:* Peerless
*Circa:* 1905

*Pattern:* Princess
*Circa:* 1910

*Pattern:* Queen Elizabeth
*Circa:* 1909

*Pattern:* Queen Victoria
*Circa:* 1909

*Pattern:* Plastron
*Circa:* 1910

*Pattern:* Pearl
*Circa:* 1900

*Pattern:* Luxfer
*Circa:* 1895

*Pattern:* Priscilla
*Circa:* 1910

Pattern: Fiddle
Circa: 1895

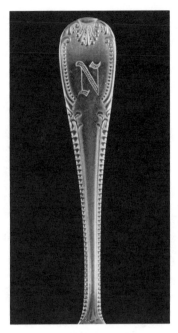

Pattern: Geisha
Circa: 1895

Pattern: Valada
Circa: 1897

Pattern: Tipped
Circa: 1895

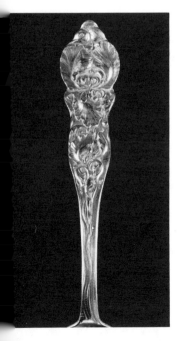

Pattern: Louvre
Circa: 1907

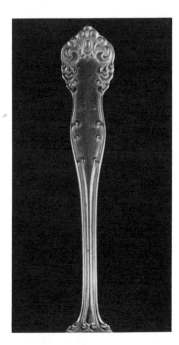

Pattern: Como
Circa: 1910

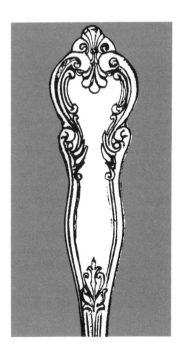

Pattern: Queen Ann
Circa: 1909

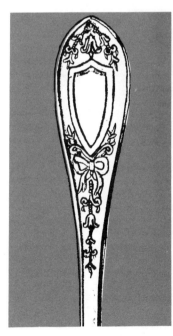

Pattern: Queen Helena
Circa: 1909
(also called Alma)

195

# Williams Bros. Mfg. Co.

*Pattern:* Windsor
*Circa:* 1900

*Pattern:* Shirley
*Circa:* 1900

*Pattern:* Norma
*Circa:* 1900

# SECTION II

# Basic Information And Terminology

# Definitions

Silverplated flatware refers to knives, forks, spoons and a variety of serving utensils made of non-precious base metal (usually an alloy) on which a thin layer of silver is plated by means of a chemical process known as electrolysis.

Alaska Silver, German Silver, Lashar Silver and Nickel Silver are often mistaken for silverplate. Such flatware contains no silver whatsoever and is merely alloy that imitates silverplate. The words "Extra $\frac{Coin}{Silver}$ Plate" on a piece of flatware does not mean that it is coin silver. On the contrary, it is a low grade silverplate. In order not to be misled into making unwise purchases it is important to understand the meaning of such terms.

Hallmark and Sheffield Plate are words generally used to describe silverplate manufactured in England. Sheffield Plate is a form of silverplate but it is produced by fusion at high temperatures instead of an electrolysis process. One should think of Sheffield Plate as an English product rather than an American product.

Two of the most extensively used base metals are Britannia and White Metal. Britannia is an alloy composed of tin, antimony and copper. White Metal has a similar composition except that lead or bismuth may be substituted for the antimony when compounding the alloy. The more tin in the base metal the whiter it looks.

The term "bleeding" is used to describe base metal showing through silverplate as a worn spot or area. Other useful definitions are:

Acanthus - leaf design
Ajouré - openwork
Amorini - cherubs or cupids
Arabesque - ornate intertwining design
Beaded - entire border of half spheres
Bright Cut - a finishing technique that produces a bright design
Bright Finish - a highly polished smooth finish
Cable - twisted rope design
Chased - design is achieved by hammered indentations
Embossed - raised surface design
Engraved - design is achieved by incising the metal surface
Geometric - triangular or rectangular design
Matte Finish - a dull appearance
Patina - a softness of finish imparted with age and use
Repoussé - raised design, hammered from the inside
Rococo - excessively ornate or intricate design

# Trademarks, Base Metal Composition And Quality Symbols

The trademark (and/or brand name) imprinted on each piece of flatware identifies the manufacturer. One manufacturing firm may have many registered trademarks. Examples are as follows:

### International Silver Company Trademarks

Albany Silver Plate
American Silver Co.
American S. P. Co.
Beacon Silver Co.
Bristol Cutlery Co.
Crown Silver Co.
Crown Silver Plate Co.
Atlas Silver Plate
Avon Silver Plate
Camelia Silverplate
Court Silver Plate
Deerfield Silver Plate
Embassy Silver Plate
Holmes & Edwards
Holmes & Tuttle Mfg. Co.
H & T Mfg. Co.
Independence
International
Kenisco
Kensington Silver Plate
Lashar

Manor Plate
Marion Silverplate
Melody Silver Plate
New England Silver Plate
Old Company
1847 Rogers Bros.
Rogers & Hamilton
R & B
R. C. Co.
1865 Wm. Rogers Mfg. Co.
Wm. Rogers & Son
Royal Plate Co.
Sheffield Plated Co.
Stratford Silver Plate Co.
Superior Silverplate
Supreme Silver Plate
Union Silver Plate Co.
Victor S. Co.
Wilcox Silver Plate Co.
Yourex

### Oneida Trademarks

Alpha Plate
Capitol Plate
Carlton Silverplate
Community Plate
Duro Plate
J. Rogers & Co.
1877 N. F. Silver Co.

1877 Niagara Falls Co.
Par Plate
Puritan Silver Co.
Reliance Plate
Tudor Plate
Wm. A. Rogers
Extra $\frac{Coin}{Silver}$ Plate

### Gorham Corporation Co.

Elmwood
Gorham E. P.
Gorham ⚓ Electro Plate
Gorham Plate

Gorham ⚓
Gorham Co. ⚓
Suffolk Silverplate
Vogue

In addition to a trademark (and/or brand name) a manufacturer will often imprint quality symbols that reflect the base metal composition. The standards are shown below. Unfortunately, not all manufacturers used them.

| | **Base Metal Symbols** | **Base Metal Percentage Composition** |
|---|---|---|
| EPC | Electroplated Copper | Self-explanatory |
| EPNS | Electroplated Nickel Silver (also called Alpacca or German Silver) | Usually 65% copper, 5 to 25% nickel, 10 to 30% zinc |
| EPBM | Electroplated Britannia Metal | Britannia is an alloy. Usually 89% tin, 7½% antimony, 3½% copper |
| EPWM | Electroplated White Metal | Composition similar to Britannia Metal except that lead or bismuth may be substituted for antimony |

| | **Silver Quantity Symbols** | **Ounces of Silver Used in Electroplating a Gross of Teaspoons** |
|---|---|---|
| XXXX | Quadruple Plate | 8 |
| XXX | Triple Plate | 6 |
| XX | Double Plate | 4 |
| A1 | Standard Plate | 2 |
| A1X | Extra Plate | 2 plus extra silver overlay on the greatest points of wear |

Because manufacturers sold pattern dies to each other, identical patterns of flatware may be found with different trademarks. Standard patterns such as Olive, Shell, Tipped and Windsor are the best examples of this fact.

**Manufacturers Sharing Common Patterns**

### Olive

L. Boardman & Son
Derby Silver Co.
Hall, Elton & Co.
Holmes, Booth & Haydens
J. O. Mead & Sons
Mulford, Wendell & Co.
Redfield & Rice

Reed & Barton
1847 Rogers Bros.
Rogers & Bros.
Rogers Bros.
Rogers Bros. Mfg. Co.
Rogers, Smith & Co.
Wm. Rogers Mfg. Co.

## Shell

American Silver Co.
Associated Silver Co.
E. A. Bliss Co.
Forbes Silver Co.
Gorham Mfg. Co.
Holmes & Edwards
Lakeside Brand
Niagara Silver Co.
Paragon Plate
Reed & Barton
1847 Rogers Bros.
Rogers & Bros.
C. Rogers & Bros.

Rogers Bros. Mfg. Co.
Rogers & Hamilton
W. F. Rogers
S. L. & G. H. Rogers
Wm. Rogers Mfg. Co.
Wm. A. Rogers
Sears
Wm. Rogers ★
E. H. H. Smith Silver Co.
Towle Mfg. Co.
R. Wallace; 1835 R. Wallace
Williams Bros.

## Tipped

American Silver Co.
Associated Silver Co.
L. Boardman & Son
Derby Silver Co.
Forbes Silver Co.
Hall, Elton & Co.
Holmes & Edwards
Lakeside Brand
Niagara Silver Co.
Oneida Community
Paragon Plate
Reed & Barton
1847 Rogers Bros.
Rogers & Bros.
Rogers Bros.
Rogers Bros. Mfg. Co.

C. Rogers & Bros.
Rogers Cutlery Co.
Rogers & Hamilton
Rogers, Smith & Co.
S. L. & G. H. Rogers
Wm. A. Rogers
Wm. Rogers Mfg. Co.
W. F. Rogers
Sears
Wm. Rogers ★
A. F. Towle & Son Co.
Towle Mfg. Co.
R. Wallace
E. G. Webster & Bros.
Williams Bros.

## Windsor

American Silver Co.
Associated Silver Co.
Derby Silver Co.
Glastonbury Silver Co.
Holmes & Edwards
Lakeside Brand
Landers, Frary & Clark
Niagara Silver Co.
Oneida Community
Reed & Barton
1847 Rogers Bros.
Rogers & Bros.

Rogers Bros.
Rogers Bros. Mfg. Co.
Rogers, Smith & Co.
S. L. & G. H. Rogers
Wm. A. Rogers
Wm. Rogers Mfg. Co.
E. H. H. Smith Silver Co.
A. F. Towle & Son Co.
Towle Mfg. Co.
1835 R. Wallace
Williams Bros.

# 200 Types Of Collectible Flatware

A. 1. Almond Scoop
A. 2. Asparagus Fork
A. 3. Asparagus Server
A. 4. Asparagus Tongs (individual)
A. 5. Asparagus Tongs (serving type)

B. 6. Baby Spoon
B. 7. Bar Spoon
B. 8. Basting Spoon (also called Dressing, Gravy, or Platter)
B. 9. Beef Fork (individual)
B. 10. Beef Fork (serving type)
B. 11. Berry Fork (individual - also called Strawberry)
B. 12. Berry Spoon (serving type)
B. 13. Bon Bon Scoop
B. 14. Bon Bon Spoon
B. 15. Bon Bon Tongs
B. 16. Bone Holder
B. 17. Bouillon Ladle
B. 18. Bouillon Spoon (individual)
B. 19. Brandy Burner
B. 20. Bread Fork
B. 21. Bread Knife
B. 22. Buckwheat Cake Lifter
B. 23. Butter Knife (flat type)
B. 24. Butter Knife (twisted handle)
B. 25. Butter Pick (serving type)
B. 26. Butter Spreader (individual)

C. 27. Cake Cutter
C. 28. Cake Fork
C. 29. Cake Knife
C. 30. Cake Server
C. 31. Carving Knife (individual)
C. 32. Carving Set (two pieces)
C. 33. Carving Set (three pieces)
C. 34. Chafing Dish Fork
C. 35. Chafing Dish Spoon
C. 36. Cheese Knife
C. 37. Cheese Scoop
C. 38. Cheese Server
C. 39. Child's Fork (individual)
C. 40. Child's Knife (individual)
C. 41. Child's Spoon (individual)
C. 42. Chocolate Muddler
C. 43. Chocolate Spoon (individual)
C. 44. Chow Chow Fork
C. 45. Chow Chow Spoon
C. 46. Claret Spoon (individual)
C. 47. Coffee Spoon (also called Demi Tasse)
C. 48. Cold Meat Fork (serving type)

C. 49. Cracker Server
C. 50. Cracker Spoon
C. 51. Crawfish Knife (individual)
C. 52. Cream Ladle (deep bowl)
C. 53. Cream Ladle (regular bowl)
C. 54. Croquette Server
C. 55. Crumb Knife
C. 56. Crumb Scraper (also called Crumb Receiver)
C. 57. Cucumber Server

D. 58. Demi Tasse Spoon (also called Coffee Spoon)
D. 59. Dessert Fork (individual)
D. 60. Dessert Knife (individual)
D. 61. Dessert Spoon (individual)
D. 62. Dressing Spoon (also called Gravy, Platter or Basting Spoon)
D. 63. Duck Knife (individual)
D. 64. Duck Shears

E. 65. Egg Server (for poached eggs)
E. 66. Egg Spoon (individual)
E. 67. Entree Server

F. 68. Fish Fork (individual)
F. 69. Fish Fork (serving type)
F. 70. Fish Knife (individual)
F. 71. Fish Knife (serving type)
F. 72. Food Pusher
F. 73. Fruit Fork (individual)
F. 74. Fruit Knife (individual)
F. 75. Fruit Knife (pocket type)
F. 76. Fruit Spoon (individual)

G. 77. Grapefruit Spoon (individual)
G. 78. Grape Shears
G. 79. Gravy Ladle
G. 80. Gravy Spoon (also called Dressing, Platter or Basting Spoon)

H. 81. Honey Spoon
H. 82. Horse Radish Spoon

I. 83. Ice Spoon
I. 84. Ice Tongs
I. 85. Ice Cream Fork (individual)
I. 86. Ice Cream Knife
I. 87. Ice Cream Ladle
I. 88. Ice Cream Server
I. 89. Ice Cream Slicer
I. 90. Ice Cream Spoon (individual)
I. 91. Iced Beverage Spoon (also called Lemonade Spoon)
I. 92. Iced Tea Spoon (individual)

J. 93. Jelly Knife
J. 94. Jelly Server
J. 95. Jelly Spoon (individual)

J.  96.   Jelly Spoon (serving type)
J.  97.   Julep Strainer

L.  98.   Lemon Fork
L.  99.   Lemon Knife
L. 100.   Lemon Server
L. 101.   Lemonade Spoon (also called Iced Beverage Spoon)
L. 102.   Lemonade Spoon - Sipper
L. 103.   Lemonade Stirrer - Sipper
L. 104.   Lettuce Fork (individual)
L. 105.   Lettuce Fork (serving type)
L. 106.   Lettuce Spoon (serving type)
L. 107.   Lobster Fork (individual)

M. 108.   Macaroni Knife
M. 109.   Macaroni Server
M. 110.   Mango Fork (individual)
M. 111.   Mayonnaise Ladle
M. 112.   Medicine Spoon
M. 113.   Melon Fork (individual)
M. 114.   Melon Fork - Knife
M. 115.   Melon Knife (individual)
M. 116.   Moustache Spoon
M. 117.   Mustard Ladle
M. 118.   Mustard Spoon

N. 119.   Nut Cracker
N. 120.   Nut Pick
N. 121.   Nut Scoop
N. 122.   Nut Spoon

O. 123.   Olive Fork
O. 124.   Olive Ladle
O. 125.   Olive Spoon
O. 126.   Olive Spoon - Fork
O. 127.   Orange Knife (individual)
O. 128.   Orange Peeler
O. 129.   Orange Spoon
O. 130.   Oyster Cocktail Fork (individual)
O. 131.   Oyster Fork (individual)
O. 132.   Oyster Fork - Spoon (individual)
O. 133.   Oyster Knife (for fried oysters)
O. 134.   Oyster Ladle
O. 135.   Oyster Scoop
O. 136.   Oyster Server
O. 137.   Oyster Server (for fried oysters)

P. 138.   Pap Spoon
P. 139.   Pastry Fork (individual)
P. 140.   Pastry Fork (serving type)
P. 141.   Pea Server
P. 142.   Pea Spoon
P. 143.   Piccalilli Spoon
P. 144.   Pickle Fork
P. 145.   Pickle Fork (long handle)
P. 146.   Pickle Knife
P. 147.   Pickle Spear - Fork

P. 148.   Pie Fork (individual)

P. 149.   Pie Knife

P. 150.   Pie Server

P. 151.   Platter Spoon (also called Gravy, Dressing or Basting Spoon)

P. 152.   Preserve Spoon

P. 153.   Pudding Spoon

P. 154.   Punch Ladle

R. 155.   Ramekin Fork (individual)

R. 156.   Roast Holder

S. 157.   Salad Fork (individual)

S. 158.   Salad Fork (serving type)

S. 159.   Salad Spoon (serving type)

S. 160.   Salad Tongs

S. 161.   Salt Spoon (individual)

S. 162.   Salt Spoon (Master Salt Spoon)

S. 163.   Saratoga Chips Server

S. 164.   Sardine Fork

S. 165.   Sardine Helper

S. 166.   Sardine Tongs

S. 167.   Sauce Ladle

S. 168.   Sherbet Spoon (individual)

S. 169.   Smelt Fork (also called Small Fish Fork)

S. 170.   Smelt Knife (also called Small Fish Knife)

S. 171.   Soup Ladle

S. 172.   Soup Spoon (individual, round bowl)

S. 173.   Spinach Fork

S. 174.   Steak Knife (individual)

S. 175.   Strawberry Fork (individual, also called Berry Fork)

S. 176.   Sugar Sifter

S. 177.   Sugar Spoon (also called Sugar Shell)

S. 178.   Sugar Tongs (serving type)

S. 179.   Sugar Tongs (small, Tete-a-tete)

T. 180.   Table Fork (individual - medium size)

T. 181.   Table Fork (individual - regular size)

T. 182.   Table Knife (individual - medium size)

T. 183.   Table Knife (individual - regular size)

T. 184.   Tablespoon (medium size)

T. 185.   Tablespoon (regular size)

T. 186.   Tea Caddy Spoon

T. 187.   Tea Fork (individual)

T. 188.   Tea Infuser

T. 189.   Tea Knife (individual)

T. 190.   Teaspoon (individual)

T. 191.   Teaspoon (afternoon type, also called P.M. or 5 O'clock Teaspoon)

T. 192.   Tea Strainer

T. 193.   Terrapin Fork (individual)

T. 194.   Toast Fork

T. 195.   Toddy Spoon (individual)

T. 196.   Toddy Strainer

T. 197.   Tomato Fork

T. 198.   Tomato Server

V. 199.   Vegetable Spoon

W. 200.  Waffle Knife

# Monograms Denoting Railroads/Railways

The majority of railroad companies utilized silverplated flatware in their dining cars. It was specially manufactured for each company, generally on a contract basis, and each piece was monogrammed to identify the railroad. So that you may identify such flatware, I have included the following list of some of the monograms and corresponding railroads. The list is by no means all-inclusive.

| Monogram | Railroad or Railway |
|----------|---------------------|
| ACL | Atlantic Coast Line |
| AT&SFe | Atchison, Topeka, & Santa Fe |
| ATSF | Atchison, Topeka, Santa Fe |
| B&M | Boston & Maine |
| B&O | Baltimore & Ohio |
| CB&Q | Chicago, Burlington & Quincy |
| C&EI | Chicago & Eastern Illinois |
| CMSP&P | Chicago, Milwaukee, St. Paul & Pacific |
| CM&StP | Chicago, Milwaukee & St. Paul |
| CNR | Canadian National Railroad |
| C&NW | Chicago & North Western |
| C&O | Chesapeake & Ohio |
| D&H | Delaware & Hudson |
| DL&W | Delaware, Lackawanna & Western |
| D&RG | Denver & Rio Grande |
| DRG&W | Denver, Rio Grande & Western |
| Erie | Erie |
| GN | Great Northern |
| IC | Illinois Central |
| L&N | Louisville & Nashville |
| LV | Lehigh Valley |
| MeCRR | Maine Central Railroad |
| MP | Missouri Pacific |
| NH | New Haven |
| NJC | New Jersey Central |
| NP | Northern Pacific |
| N&W | Norfolk & Western |
| NYC | New York Central |
| NYNH&H | New York, New Haven & Hartford |
| NYO&W | New York, Ontario & Western |
| PRR | Pennsylvania Railroad |
| RF&P | Richmond, Fredericksburg & Potomac |
| RI | Rock Island |
| So | Southern |
| SP | Southern Pacific |
| SR | Southern Railway |
| T&PR | Texas & Pacific Railway |
| UP | Union Pacific |
| Wabash | Wabash Railroad |
| WP | Western Pacific |

# Reasons For Investing In Silverplated Flatware

Silverplated flatware represents a sound investment. To understand why let me focus your attention on its current uses and help you obtain a perspective of its already limited availability.

Modern industry consumes millions of ounces of commercial silver and the demand increases each year. The photographic industry depends on it. Silver is used in all mirrors and in almost every electronic device. It is a catalyst that triggers and accelerates numerous chemical reactions which are the basis for manufacturing synthetic fabrics (permanent press) and an astounding variety of plastic objects. In medicine silver wire repairs skull injuries and keeps broken bones in place. Bone joints and sockets are repaired with silver coated bearings. Silver nitrate creams provide antiseptic treatment for severe burns. These are only a few medical applications.

Women of all ages and in every generation adorn themselves with jewelry, and there is a current trend in advertising which encourages men to buy and wear silver necklaces and bracelets. There is no decrease in silver consumption in view for the jewelry industry. As inflation continues more individuals are investing in silver jewelry.

Privately owned mints are producing and selling an ever increasing variety of commemorative medals and coins, plates, ingots and other collectibles. When we consider the millions of ounces of silver used annually by these mints, plus the amounts used by the industries listed above and the well known manufacturers of silverplated articles, we come face to face with the concept of scarcity.

As I explained in one of my earlier books on the subject of silverplated flatware, a scarcity of silver has existed in this country since 1964 when the U. S. government stopped minting and distributing silver coins. The government conducted a large coin melt at that time and converted silver earmarked for coinage to silver for commercial purposes. The discontinuance of copper in coins was also planned but has been delayed because of vending machine lobbyist activity. Coins have to be devised that existing vending machines can accommodate. At any rate, one can predict that silverplate having base metal with a 65% copper content will increase in value the minute copper pennies are replaced.

Although the major silverware manufacturers such as International Silver Co., Gorham Corporation and Oneida Silversmiths continue to produce a few patterns of silverplated flatware, the majority of retail stores do not stock complete sets. Stores have place setting examples of the current patterns but a complete set must be specially ordered. This fact alone is indicative that silverplated flatware per se is almost a closed collecting category as of this decade.

Stainless steel flatware and disposable plastic utensils have replaced the silverplated utensils that predominated in homes, hotels, restaurants and trains between the 1870s and 1930s.

Since the 1940s thousands upon thousands of pieces of silverplated flatware have been converted to spoonhandle rings and bracelets, fork tine necklace pendants, wind chimes and napkin rings. Such flatware is not available for collection; therefore, scarcities of certain flatware patterns already exist.

# Utilization, Care and Cleaning

One of my fondest childhood memories is the way the holiday table was always set with the treasured contents of my mother's china closet. The cut glass vases, the "best china," linen and silver to this day sparkle with cleanliness in my mind's eye the same as they did on the table years ago. And so it is that I carry on the tradition in my own home. I wonder, however, in view of current life styles, what memories of meals the children of today will have as adults of tomorrow. It appears as if it will soon be the average family's custom to eat all holiday meals in restaurants. But for those of you who cherish the old ways here is a chart that will help you to utilize silverplated flatware in appropriate table settings.

| MEAL | MENU | APPROPRIATE FLATWARE | TABLECLOTH, NAPKINS & PLATES |
|------|------|----------------------|------------------------------|
| Breakfast | Coffee<br>Toast<br>Bacon & Eggs<br>Cereal<br>Grapefruit | Teaspoon<br>Butter Spreader<br>Dessert Knife & Fork<br>Dessert Spoon<br>Grapefruit Spoon | 8" Plates<br>Place Mats on a Bare Table<br>Napkins Should Match Place Mats |
| Lunch | Oyster<br>Bouillon<br>Meat &<br>  Vegetables<br>Salad<br>Dessert<br>Coffee | Oyster Fork<br>Bouillon Spoon<br>Luncheon Knife &<br>  Fork<br>Salad Fork<br>Dessert Fork<br>After Dinner Coffee<br>  Spoon | 10" Plate<br>18" Napkin that Matches Tablecloth |
| Afternoon Tea | Tea<br>Assorted Tiny<br>  Sandwiches<br>Hot Biscuits<br>Fancy Cakes | Tray<br>Teakettle<br>Teapot<br>Creamer<br>Sugar Bowl<br>Waste Bowl<br>Teaspoons<br>Sugar Tongs<br>Lemon Fork | 8" Plate<br>12" Napkin<br>Lace Tablecloth |
| Dinner | Soup<br>Salad<br>Fish<br>Meat &<br>  Vegetable<br>Dessert<br>Coffee, Demi<br>  Tasse | Soup Spoon<br>Salad Fork<br>Fish Knife & Fork<br>Dinner Knife & Fork<br><br>Dessert Fork & Spoon<br>Demi Tasse Spoon | 10" Plate<br>19" Napkin<br>Ivory, Beige or Pastel Shade Damask Tablecloth |

Always position the bread and butter plate on the upper right side of the breakfast, luncheon or dinner plate with an individual butter spreader placed diagonally across it. Spoons and knives are always placed on the right side of the plate making certain that the cutting edge of the knife faces the plate. All forks except for the oyster or cocktail forks are positioned on the left side of the plate. Positioning in addition to this basic arrangement is based on the order of use beginning at the outside and working towards the plate as each course is served.

Refer to the Index to Collectible Flatware, pages 202 through 205. Match serving pieces to your menus and you may be certain that your table setting will be interesting, glamorous, and long remembered by your family and friends.

Silverplated flatware should be washed immediately after use in hot soapy water. To avoid scratches put only a few pieces at a time in the basin of water. Then rinse each piece thoroughly. Hot running tap water is preferred. Dry each piece very carefully and thoroughly. If dried directly from the soapy water, it will tarnish rapidly. Although tarnishing can never be prevented, it can be delayed. Keep it out of contact with air, preferably in drawers with pieces of camphor in them or in silver chests lined with felt. The sulfur in the air, in foods like eggs, in matches and rubber will cause rapid tarnishing.

In the event flatware is badly tarnished, abrasive creams or chemical cleaning solutions should be used to clean it. Such products are readily available in department stores and supermarkets. The fine polishing should be accomplished with a glove or cloth treated with jeweler's rouge. Baking soda may be used in a pinch as a substitute for the jeweler's rouge. Always rinse the flatware under hot running tap water after using abrasive creams, chemical solutions or the specially treated glove, making certain that each piece is thoroughly dried. Never allow silverplated flatware to be immersed in water for long periods of time and never place rubber bands around it.

Keeping these few simple rules in mind it will be easy to keep flatware in bright, beautiful condition and ready for use.

# Limited Service Patterns

Although I have listed 200 types of collectible flatware it does not mean that a collector will be able to find one of each type for each pattern shown in this book. The limited service patterns introduced under the 1847 Rogers Bros. trademark in 1892 provide the best examples of this fact. A collector may expect to find the following 1847 Rogers Bros. patterns only in the type of flatware specified below.

Alpine — coffee spoons and oyster forks
Berkeley — orange spoons
Brunswick — ice cream forks and orange spoons
Clover — Julep strainers
Colonade — Horseradish spoons
Columbian I — carving sets
Coral — coffee spoons and oyster forks
Cordova — coffee spoons and oyster forks
Daisy — coffee spoons and oyster forks
Delmonico I — oyster forks
Florentine I — coffee spoons
Florentine II — sardine forks
Florentine III — bon bon spoons
Florentine IV — carving sets
Florida — orange spoons
French — ice cream spoons
Game — coffee spoons and oyster forks
Gem — carving sets
Grecian — carving sets
Harvard — bon bon spoons and orange spoons
Hoffman II — Julep strainers
Horn of Plenty — carving sets
Kensington — sardine tongs
Lenox I — fruit forks
Lenox II — Horseradish spoons
Lorraine — coffee spoons and oyster forks
Majestic — fish knives, fish forks and berry spoons
Norwegian — cheese scoops and cheese knives
Pearl — coffee spoons and oyster forks
Pistol Handle — carving sets
Plazza — butter spreaders
Primrose — coffee spoons and oyster forks
Royal — cheese scoops
Ruby — coffee spoons and oyster forks
Sabre Handle — carving sets
Scythian — berry spoons and crumb knives
Shrewsbury — oyster forks
Star — Julep strainer
Stockbridge — orange spoons
Swiss — carving sets and butter spreaders
Tolland — bon bon spoons
Vassar — bon bon spoons
Yale — orange spoons

# Bibliography

**Books**

Alexander, Edwin P. *Down at the Depot — American Railroad Stations from 1831 to 1920*. New York: Bramhall House, 1920.

Carabini, Louis E. *The Case of Silver*. Second Edition.: Pacific Coast Coin Exchange, Monex International, Ltd., 1974.

Cohen, Hal L. *Antiques and Curios, The Price to Buy & Sell*. New York: House of Collectibles, Inc., 1973.

Cohen, Hal L. *Official Guide to Silver & Silverplate*. New York: House of Collectibles, Inc., 1974.

Davis, Fredna Harris, and Deibel, Kenneth K. *Silverplated Flatware Patterns*. Dallas: Bluebonnet Press, 1972.

Delieb, Eric. *Investing in Silver*. New York: Clarkson N. Potter, Inc., 1967.

Eaton, Allen H. *Handicrafts of New England*. New York: Harper & Brothers Publishers, 1949.

Edmonds, Walter D. *The First Hundred Years*. New York: Oneida, Lts. Oneida, 1958.

Ensko, Robert. *Makers of Early American Silver*. New York: Trow Press, 1915.

Freeman, Larry, and Beaumont, Jane. *Early American Plated Silver*. New York: Century House, Watkins Glenn, 1947.

Hardt, Anton. *Adventuring Further in Souvenir Spoons*. New York: Greenwich Press, 1971.

Hughes, G. Bernard. *Small Antique Silverware*. New York: Bramhall House, 1957.

Hughes, Graham. *Modern Silver*. New York: Crown Publishers, 1967.

Ingwerson, R. S., and Davis, D. G. *A Textbook of Electroplating*. Palm Bay, Florida: Tropic House, 1973.

Jones, E. Alfred. *Old Silver of Europe and America*. Philadelphia: Lippincott Co., 1928.

Kauffman, Henry J. *The Colonial Silversmith — His Techniques & His Products*. New Jersey: Thomas Nelson, Inc., 1969.

Kovel, Ralph and Terry. *The Kovel's Complete Antiques Price List*. New York: Crown Publishers, Inc., 1976.

Kovel, Ralph M. and Terry H. *A Directory of American Silver, Pewter and Silverplate*. New York: Crown Publishers, 1961.

Link, Eva M. *The Book of Silver*. New York: Praeger Publishers, 1973.

Luckey, Carl F. *Official Price Guide to Silver — Silverplate and Their Makers*. Alabama: House of Collectibles, 1978.

MacLachlan, Suzanne. *A Collector's Handbook for Grape Nuts*. California: Suzanne MacLachlan, 1971.

May, Earl Chapin. *A Century of Silver, 1847-1947*. New York: Robert M. McBride, & Company, 1947.

McClinton, Katharine Morrison. *Antiques Past and Present*. New York: Clarkson N. Potter, Inc., 1971.

Mebane, John. *The Coming Collecting Boom*. Cranberry, New Jersey: A. S. Barnes and Co., Inc., 1968.

Miller, R. W., ed. *Wallace-Homestead Price Guide to Antiques and Pattern Glass,* First Edition. Des Moines, Iowa: Wallace-Homestead Book Co., 1973.

Okie, Howard Pitcher. *Old Silver and Old Sheffield Plate.* New York: Doubleday, Doran and Company, 1928.

Phillips, John Marshall. *American Silver.* New York: Chanticleer Press, 1949.

Phillips, John Marshall. *The Practical Book of American Silver.* Philadelphia: Lippincott, 1949.

Semon, Kurt M. *A Treasury of Old Silver.* New York: The McBride Co., 1947.

Snell, Doris Jean. *Art Nouveau & Art Deco Silverplated Flatware.* Des Moines, Iowa: Wallace-Homestead Book Co., 1976.

Snell, Doris Jean. *100 Silver Collectibles.* Des Moines, Iowa: Wallace-Homestead Book Co., 1973.

Snell, Doris Jean. *Silverplated Flatware.* Des Moines, Iowa: Wallace-Homestead Book Co., 1971.

Snell, Doris Jean. *Victorian Silverplated Flatware.* Des Moines, Iowa: Wallace-Homestead Book Co., 1975.

Snodin, Michael, and Belden, Gail. *Collecting for Tomorrow — Spoons.* Radnor, Pennsylvania: Chilton Book Company, 1976.

Stow, Millicent. *American Silver.* New York: Gramercy Publishing Company, 1950.

Strauch, Ida, and Hansen, Elizabeth. *Silverplate Directory.* California: Ida Strauch and Elizabeth Hansen, 1971.

Taylor, Gerald. *Art in Silver and Gold.* London: Studio Vista Limited, 1964.

Thorn, C. Jordan. *Handbook of American Silver and Pewter Marks.* New York: Tudor Publishing Co., 1949.

Turner, Noel D. *American Silver Flatware 1837-1910.* South Brunswick: A. S. Barnes and Company, 1972.

Wardle, Patricia. *Victorian Silver and Silver-Plate.* New York: Universe Books, 1970.

Wenham, Edward. *Domestic Silver of Great Britain and Ireland.* New York: Oxford University Press, 1931.

Wenham, Edward. *Practical Book of American Silver.* New York: J. B. Lippincott Company, 1949.

## Catalogs

Annual Catalog, Diamonds — Jewelry, Watches and Silverware. New York: H. M. Manheim & Co., 1941.

Annual Catalog, Diamonds — Jewelry, Watches and Silverware. New York: H. M. Manheim & Co., 1942.

Annual Catalog, Diamonds — Jewelry, Watches and Silverware. New York: H. M. Manheim & Co., 1943.

Baird-North Co. Diamonds, Watches, Jewelry, Silverware. Providence, R.I. Des Moines, Iowa: Wallace-Homestead Book Co., Reprint of 1913 catalog.

Catalog of Albert Pick & Co. Chicago: 1910-11.

Catalogue of Electro Plated Flatware. Providence, R.I.: The Gorham Co., 1911.

Catalogue No. 50. New York: Wm. Rogers Ltd.,

Catalogue of Gorham Mfg. Co., Providence R.I.: Autumn, 1888.

Catalog L. Baird-North Company. Providence, Rhode Island: 1908.

Catalog of Montgomery Ward and Co.: 1896 through 1958.

Catalog P.S. Kind & Sons. Philadelphia: 1912.

Catalogue of Rogers & Hamilton. Waterbury, Connecticut: 1888.

Catalog of Sears, Robuck & Co.: 1888 through 1960.

Catalog 74. Larkin Co. Buffalo, New York: 1915.

Catalog 62. Joseph Hagn Co. Chicago: 1925.

Catalog 33. Joseph Hagn Co. Chicago: 1935.

Catalog of Wm. Rogers Mfg. Co. Hartford, Connecticut: 1892.

1847 Rogers Brothers Patterns: Meriden, Conn. International Silver Company.

Illustrated Catalogue of the Jewelry Department. Marshall Field & Co., Chicago: 1887.

Illustrated Catalogue, Jewelry & Fashions. Marshall Field & Co., Chicago: 1896.

Illustrated Fort Dearborn Gift Book & General Catalog. Fort Dearborn Watch & Clock Co., Chicago: 1932.

Illustrated Wholesale Price List and Catalogue. The Fort Dearborn Watch and Clock Co., Chicago: 1910.

Macy 17. R. H. Macy & Co., New York: 1917.

## Periodicals

The Jewelers' Circular-Keystone. Philadelphia: Chilton Publication, Selected Issues, 1969-1973.

The Magazine Silver.   Selected Issues, Silver-Rama, 1968-1978.

"Trade Marks of the Jewelry and Kindred Trades". Jewelers Circular-Keystone. New York and Philadelphia: 1904, 1910, 1915, 1965, 1973.

"The Art of Silver Replating and Repair". Simmons Silver Plating Co., Inc., Atlanta, Georgia: no date.

"The Story of Sterling". The Sterling Silversmiths Guide of America, New York: 1937.

In addition to the above, reference was also made to consumer brochures and magazine articles too numerous to mention.

Belmont — ★ Rogers & Bros. 147
Beloved — ⚜ Wm. Rogers ★ 126
Beloved — Meriden Silver Plate Co. 54
Belvedere — ⊞ W. R. ⛉ 151
Benedict No. 2 — Benedict Mfg. Co. 16
Berkeley — 1847 Rogers Bros. 94
Berkley Square — Oneida Community 63
Berkshire — 1847 Rogers Bros. 90
Berlin — American Silver Co. 13
Berlin — R. C. Co. 136
Berlin — Wm. Rogers Mfg. Co. 161
Berwick — ⚜ Wm. Rogers ★ 122
Berwick — Wm. Rogers Mfg. Co. 158
Berwick — Simpson, Hall, Miller & Co. 175
Betsy Ross — Stratford Silver Co. 178
Beverly — Oneida Community - Duro Plate 68
Beverly — 1881 Rogers 107
Bird of Paradise — Oneida Community 64
Blackstone — Gorham 32
Blenheim — ⚜ Wm. Rogers ★ 119
Blenheim — Wm. Rogers Mfg. Co. 158
Blossom — 1835 R. Wallace 188
Blue Point — ⚜ Wm. Rogers ★ 119
Bordeau — Prestige Plate 76
Bouquet — Derby Silver Co. 24
Bouquet — Embassy Silver Plate 26
Bouquet — Plymouth Silver Plate 76
Bouquet — Utility Silverplate 185
Bradford — Gorham 32
Bradford — Holmes & Tuttle Mfg. Co. 47
Briar Rose — 1881 Rogers 105
Bridal Corsage — Tradition Silverplate 183
Bridal Rose — N. F. Silver Co. 61
Bridal Song — Tradition Silverplate 184
Bridal Wreath — Oneida Community - Par Plate 69
Bridal Wreath — Oneida Community - Tudor Plate 72
Brides Bouquet — Alvin 11
Bright Future — Holmes & Edwards 44
Brittany Rose — Wm. A. Rogers 156
Broadfield — Salem Silver Plate 173
Brunswick — L. Boardman & Son 19
Brunswick — 1847 Rogers Bros. 86
Buckingham — 1835 R. Wallace 189
Burgundy — ⚜ Wm. Rogers ★ 125
Burgundy — Wm. Rogers & Son 172
Burlington — ⚓ Rogers ⚓ 115

# C

Cabin — Wm. Rogers Mfg. Co. 164
California Blossom — Wm. Rogers Mfg. Co. 163
Camden — Marion Silver Plate 52

Cameo — Alvin 11
Capri — 1881 Rogers 108
Caprice — Nobility Plate 61
Cardinal — Heirloom Plate 37
Cardinal — ⚓ Rogers ⚓ 114
Cardinal — ⚜ Wm. Rogers ★ 119
Cardinal — Rogers & Hamilton 138
Cardinal — 1835 R. Wallace 186
Cardinal — E. G. Webster & Bros. 192
Careta — Oneida Community 62
Careta — Oxford Silver Co. 73
Carlton — Reed & Barton 81
Carlton — 1881 Rogers 106
Carlton — Wm. A. Rogers 152
Carmen — Stratford Silver Co. 178
Carnation — ⊞ W. R. ⛉ 150
Carnation — Wm. A. Rogers 153
Carolina — Holmes & Edwards 42
Caroline — Gorham 34
Cashmere — Reed & Barton 79
Cavalcade — National Silver Co. 58
Cavalier — Gorham 31
Cedric — ⚜ Wm. Rogers ★ 119
Century — Holmes & Edwards 43
Chalfonte — Wm. Rogers Mfg. Co. 161
Chalon — Cambridge Silver Plate 20
Chalon — Paragon Silver Plate 75
Champlain — ⚜ Wm. Rogers ★ 122
Charm — Holmes & Edwards 45
Charter Oak — 1847 Rogers Bros. 99
Chateau — Heirloom Plate 37
Chatham — R. C. Co. 137
Chatsworth — Holmes & Edwards 42
Chelsea — C. Rogers & Bros. 117
Chelsea — Wm. Rogers Mfg. Co. 160
Cheshire — 1881 Rogers 104
Chester — Wm. Rogers & Son 165
Chester — Towle Mfg. Co. 182
Chevalier — ⚓ Rogers ⚓ 111
Chevalier — Wm. Rogers Mfg. Co. 160
Chevron — 1881 Rogers 105
Chicago — Montgomery Ward 55
Chippendale — 1881 Rogers 104
Churchill — Gorham 31
Cinderella — Niagara Silver Co. 60
Citrus — Wm. Rogers Mfg. Co. 165
Clarendon — Reed & Barton 80
Claridge — ⚜ Wm. Rogers ★ 124
Claridge — Wm. Rogers Mfg. Co. 163
Clarion — Oneida Community - Par Plate 69
Classic — Alvin 11
Classic — Oneida Community 63
Classic Filigree — Harmony House Plate 36
Classic Filigree — Tradition Silverplate 183

# D

# I

Ideal — R & B  128
Ideal — Rogers & Hamilton  138
Imperial — L. Boardman & Son  19
Imperial — Holmes & Edwards  41
Imperial — 1847 Rogers Bros.  96
Imperial — ⚓ Rogers ⚓  114
Imperial — C. Rogers & Bros.  118
Imperial — 🦅 Wm. Rogers ★  126
Imperial — Rogers & Hamilton  138
Imperial — ★♥ Rogers Smith & Co.  140
Imperial — W. F. Rogers  157
Imperial — Wm. Rogers & Son  166
Inauguration — Diamond Silver Co.  26
Inauguration — National Silver Co.  58
India — Holmes, Booth & Haydens  46
Inheritance — Wm. Rogers Mfg. Co.  163
Inspiration — ★ Rogers & Bros.  149
Invitation — Gorham  31
Ionic — A. F. Towle & Son Co.  182
Iris — Paragon Silver Plate  74
Iris — Salem Silver Plate  174
Iris — E. H. H. Smith Silver Co.  176
Iroquois — Niagara Silver Co.  59
Irving — Holmes & Edwards  42
Irving — ⊞ W. R. ♉  151
Isabella — R. C. Co.  136
Italian — Reed & Barton  80
Ivanhoe — Hibbard, Spencer, Bartlett & Co.  37
Ivy — 1847 Rogers Bros.  92
Ivy — Rogers & Bros.  132
Ivy (Grape) — Wm. Rogers & Son  165

# J

Jay Rose — Holmes & Edwards  40
Jamestown — Holmes & Edwards  42
Janet — 1881 Rogers  106
Japanese — Holmes, Booth & Haydens  46
Jasmine — Simeon L. & George H. Rogers  144
Jefferson — Simeon L. & George H. Rogers  143
Jewel — Plymouth Silver Plate  76
Jewel — Simpson, Hall, Miller & Co.  175
Jewell — Marion Silver Plate  52
Jewell — R & B  128
Joan — 1835 R. Wallace  187
Jubilee — Wm. Rogers Mfg. Co.  165
Juliet — Cambridge Silver Plate  21

Juliette — Wm. Rogers & Son  172
June — Oneida Community - Tudor Plate  71
Justice — 1881 Rogers  105

# K

Kensico — Williams Bros. Mfg. Co.  193
Kensington — 1847 Rogers Bros.  90
Kenwood — Oneida Community - Reliance Plate  70
King — Holmes & Edwards  40
King — 🦅 Wm. Rogers ★  123
King Cedric — Oneida Community  64
King Edward — National Silver Co.  58
King Francis — Reed & Barton  82
King Frederik — 1847 Rogers Bros.  102
King George — Holmes & Tuttle Mfg. Co.  47
Kings — Gorham  33
Kings — Reed & Barton  80
Kings — 1847 Rogers Bros.  89
Kings — E. H. H. Smith Silver Co.  177
Kings — 1835 R. Wallace  186
Kingston — Simeon L. & George H. Rogers  146

# L

La Concorde — Wm. A. Rogers  154
Lady Alice — Fashion Silver Plate  28
Lady Alice — 1835 R. Wallace  188
Lady Caroline — Gorham  32
Lady Claire — Cambridge Silver Plate  21
Lady Doris — Lady Doris Silver Plate  49
Lady Fair — 🦅 Wm. Rogers ★  126
Lady Grace — Cambridge Silver Plate  20
Lady Grace — National Silver Co.  58
Lady Joan — Fashion Silver Plate  28
Ladyship — Stratford Silver Co.  178
Lafayette — Alvin  11
Lafayette — Benedict Mfg. Co.  16
Lafayette — Holmes & Edwards  41
La France — Wm. Rogers & Son  168
Lakewood — Lakeside Brand  50
Lakewood — Simeon L. & George H. Rogers  142
Lancaster — Alvin  10
Lancaster — Rockford Silver Plate Co.  84
Lancaster — Wm. Rogers & Son  172
La Rose — Oneida Community - Reliance Plate  70
LaSalle — Holmes & Tuttle Mfg. Co.  47
LaSalle — Reed & Barton  80
LaSalle — Wm. Rogers & Son  169
LaTouraine — ⚓ Rogers ⚓  112

Mayflower — C. Rogers & Bros. 117
Mayflower — ⚓ Rogers ⚓ 111
May Queen — Holmes & Edwards 44
Maytime — Harmony House Plate 36
Maytime — Tradition Silverplate 183
Maytime — Wallingford Co. 192
Meadowbrook — 1881 Rogers 104
Meadowbrook — Wm. A. Rogers 156
Medallion — L. Boardman & Son 19
Medallion — Hall, Elton, & Co. 35
Medallion — Reed & Barton 77
Medallion — Simpson, Hall, Miller & Co. 175
Medallion — R. Strickland 180
Melody — Alvin 11
Melody — Melody Silver Plate 53
Melrose — ⚜ Wm. Rogers ★ 119
Melrose — Simpson, Hall, Miller & Co. 175
Memory — ⚜ Wm. Rogers ★ 125
Merrill — R. C. Co. 137
Micado — ⚜ Wm. Rogers ★ 120
Mignon — Montgomery Ward 55
Milady — Oneida Community 65
Milam — 1847 Rogers Bros. 90
Milton — Wm. Rogers & Son 166
Minerva — Simeon L. & George H. Rogers 143
Minnehaha — Holmes & Edwards 41
Mistletoe — Montgomery Ward 55
Mode — 1835 R. Wallace 190
Modern Art — Reed & Barton 81
Modern Baroque — Oneida Community 66
Modern Rose — ⚜ Wm. Rogers ★ 126
Moline — 1847 Rogers Bros. 91
Moline — ★♥ Rogers Smith & Co. 140
Moline — Wm. Rogers & Son 166
Molly Stark — Alvin 10
Monarch — Meriden Britannia Co. 54
Monarch — Montgomery Ward and Co. 57
Monarch — Rogers & Bros. 131
Monarch — Rogers & Hamilton 138
Monticello — American Silver Co. 13
Moonlight — ⚓ Rogers ⚓ 115
Morning Glory — Harmony House 36
Morning Glory — Tradition Silverplate 183
Morning Glory — 1835 R. Wallace 157
Morning Rose — Oneida Community 67
Morning Star — Oneida Community 66
Moselle — American Silver Co. 14
Moselle — 1847 Rogers Bros. 88
Moss Rose — King Edward Silver Plate 48
Mount Royal — Wm. Rogers Mfg. Co. 162
Muscatel — Paragon Silver Plate 75
Myrtle — Montgomery Ward 55
Mystic — ★ Rogers & Bros. 148

## N

Napoleon — Holmes & Edwards 43
Narcissus — Oxford Silver Co. 73
Nassau — Holmes & Edwards 40
Nassau — Stratford Silver Co. 179
Navarre — ★ Rogers & Bros. 147
Nenuphar — American Silver Co. 13
Nevada — 1847 Rogers Bros. 87
New Century — Rogers & Bros. 132
New Daisey — Wm. Rogers Mfg. Co. 162
New Elegance — Gorham 31
New Emperor — Reed & Barton 82
Newington — Universal Silver 185
Newport — Holmes & Edwards 44
Newport — Newport Silver Plate 59
Newport — 1847 Rogers Bros. 98
Newport — ⚓ Rogers ⚓ 115
Newport — Rogers & Bros. 133
Newport — Rogers & Hamilton 138
Newport — ★♥ Rogers Smith & Co. 140
Newtown — Cambridge Silver Plate 21
Noblesse — Oneida Community 64
Norfolk — 1847 Rogers Bros. 91
Norma — Montgomery Ward 55
Norma — Williams Bros. Mfg. Co. 195
Normandy — Reed & Barton 80
Norwegian — 1847 Rogers Bros. 91
Norwood — Towle Mfg. Co. 182
Nuart — ▨ W. R. ⬯ 151
Nuart — Wm. A. Rogers 155
No. 300 — A.F. Towle & Son Co. 182

## O

Oak — E. H. H. Smith Silver Co. 176
Old Colony — 1847 Rogers Bros. 99
Old French — Tiffany & Co. E. P. 180
Old London — Reed & Barton 82
Olive — L. Boardman & Son 18
Olive — Derby Silver Co. 24
Olive — Hall, Elton & Co. 35
Olive — Holmes, Booth & Haydens 46
Olive — J. O. Mead & Sons 53
Olive — Mulford, Wendell & Co. 57
Olive — Reed & Barton 78
Olive — 1847 Rogers Bros. 96
Olive — ⚓ Rogers ⚓ 113
Olive — Rogers & Bros. 133
Olive — Rogers Bros. 134
Olive — Rogers Bros. Mfg. Co. 135
Olive — ★♥ Rogers Smith & Co. 141
Olive — Wm. Rogers Mfg. Co. 161
Olive — Simpson, Hall, Miller & Co. 175

The photographs on the following pages were taken from *Art Nouveau and Art Deco Silverplated Flatware* By Doris Jean Snell (Des Moines: Wallace-Homestead, 1976): Monticello-13, Roanoke-13, Moselle-14, Adonis-14, Peerless-15, Roxbury-27, Regent-31, Empire-33, Commodore-33, Orient-42, Chatsworth-42, Carolina-42, Jamestown-42, Charm-45, LaSalle-47, King George-47, Bradford-47, Westfield-54, Classic-63, Avalon-63, Paul Revere-64, Deauville-65, Primrose-69, Wildwood-70, Kenwood-70, Mary Stuart-70, Careta-73, Garland-73, Narcissus-73, Puritan Grape I-76, Puritan Grape II-76, Modern Art-81, Belmont-81, Mayfair-99, Sharon-99, Salem-99, Faneuil-100, Queen Ann-100, Chippendale-104, Cheshire-104, Alhambra-112, Beauty-112, General Putman-112, LaTouraine-112, Beauty-112, Puritan-113, Argyle-113, Chelsea-117, Poppy-127, Manor-128, Corona-136, Isabella-136, Manchester-136, Rose-137, Vendome-137, Orleans-137, Chatham-137, Doric-139, Marquis-139, Minerva-143, Jefferson-143, Pansy-143, Lexington-143, Arcadia-145, Webster-145, Roxbury-145, Commodore-145, Orchid-146, Encore-146, Grenoble-154, Concord-154, Chalfonte-161, Raleigh-162, Mount Royal-162, Essex-168, Hampden-168, Daisey-170, Triumph-170, Conant-173, Iris-176, Holly-176, Antique Egyptian-177, Lilyta-179, Rosedale-179, Troy-186, Floral Variation-186, Cardinal-186, Laurel-186, Floral-189, Trenton-190, Trumpet Vine-191, Sharon-191, Adams-192.

The photographs on the following pages were taken from *Silverplated Flatware* By Doris Jean Snell (Des Moines: Wallace-Homestead, 1971): Lexington-10, George Washington-10, Lady Grace-20, Florence-23, Century-43, Danish Princess-44, Georgian-63, Louis XVI-63, Sheraton-63, Grosvenor-63, Adam-64, Noblesse-64, Patrician-64, Bird of Paradise-64, King Cedric-64, Coronation-64, Vernon-69, Bridal Wreath-69, La Rose-70, Exeter-70, Queen Bess-70, Skyline-70, Baronet-71, Duchess-71, Arcadian-87, Assyrian-87, Columbia-88, Savoy-88, Kings-89, Portland-89, Vesta-90, Berkshire-91, Tipped-97, Shell-97, Persian-97, Newport-98, Beaded-98, Embossed-98, Lotus-98, Priscilla-98, Avon-98, Vintage-99, Charter Oak-99, Old Colony-99, Cromwell-99, Heraldic-99, Louvain-100, Ambassador-100, Anniversary-100, Ancestral-100, Silhouette-100, Adoration-100, Argosy-101, Legacy-101, Eternally Yours-101, Reflection-101, Grecian-104, Leyland-104, Meadowbrook-104, Delmar-104, Empress-106, Lavigne-106, Lexington-111, Mayflower-111, Dunraven-114, Cardinal-114, York-119, Diana-120, Puritan-124, Colillion-125, Regent-125, Desire-125, Aldine-138, Tudor-138, Carnation-150, Leonora-150, Croydon-156, Meadowbrook-156, Flower-163, Claridge-163, Priscilla-164, Admiration-164, Cabin-164, Magnolia-164, Lyonnaise-165, Chester-165, Crown-167, Oxford-167, Orange Blossom-168, Sunkist-168, Lafrance-168, Mayfair-168, Clinton-169, Lincoln-169, Paris-170, Georgic-170, Gardenia-171, Exquisite-171, Talisman-171, April-171.

The photographs on the following pages were taken from *Victorian Silverplated Flatware* By Doris Jean Snell (Des Moines: Wallace-Homestead, 1975): Tours-14, DeWitt-16, Medallion-19, Princess Louise-31, Winthrop-32, Richmond-32, Eastlake-35, Palace-35, Eastlake-39, Angelo-39, Leader-39, Greek-39, Delsart-39, Rialto-39, Japanese-46, Roman-46, St. Paul-47, Lorraine-47, Croyden-73, Arlington-73, Gem-78, Unique-78, Parisian-79, Cashmere-79, Italian-80, Clarendon-80, Rex-81, Carlton-81, Primrose-90, Harvard-91, Moline-91, Norfolk-91, Roman-93, Laurel-93, Lorne-93, Shell Tip-94, Gothic-94, Threaded-96, Silver-96, Tuscan-96, Oval-96, Imperial-96, Crown-97, Assyrian Head-97, Dundee-97, Siren-97, Etruscan-97, Hartford-109, Roman-109, Opal-110, Cromwell I-110, Princess-111, Lilian-111, Plymouth-114, Newport-115, Assyrian-115, Alaska-116, Winthrop-116, Royal-116, Westminster-117, Countess-118, St. James-118, Athens-119, Blenheim-119, Cardinal-119, Melrose-119, San Diego-120, Geneva-120, Egyptian-122, Cordova-123, Attica-127, Thistle-127, Oval-129, Persian-129, Tuscan-131, Gothic-132, Columbia-132, New Century-132, Princess-133, Newport-133, Saratoga-133, Olive-133, Tuxedo-133, Raphael-139, Shell-139, Majestic-139, Marquis-139, Elberon-152, Warwick-152, Arundel-153, Hanover-153, Lotus-173, Chester-182, Norwood-182, Anjou-186, Stuart-186, Diamond-187, Joan-187.